T0155416

THE STORY OF BASS

THE RISE AND DEMISE OF A BREWING GREAT

HARRY WHITE

AMBERLEY

Acknowledgements

I would like to thank John Arguile for getting me started on this and for permission to use his two timelines. I would also like to thank Terry Critchley and Andrew Richards for their help in reproducing many of the images.

The illustration entitled *Wagon* is by W. H. Pyne from *The Costume of Great Britain*, 1808, engraved and written by W. H. Pyne, and is reproduced here under a Creative Commons Attribution Non-Commercial Licence from the Science Museum Group Collection.

The photo of The Oxford Arms in Warwick Lane is reproduced under the terms of a Creative Commons Attribution Non-Commercial Licence from The Royal Academy of Arts.

The two illustrations provided by A. A. Meldrum are from the Jimmy Simpson Collection of Wellpark Brewery memorabilia, in the Scottish Brewing Archives section of the Glasgow University Business Archives (currently held in 'The Tennent's Story' Visitor Centre, Wellpark Brewery, Glasgow).

First published 2022

Amberley Publishing
The Hill, Stroud,
Gloucestershire, GL5 4EP

www.amberley-books.com

Copyright © Harry White, 2022

The right of Harry White to be identified as the Author
of this work has been asserted in accordance with the
Copyright, Designs and Patents Act 1988.

All rights reserved. No part of this book may be reprinted
or reproduced or utilised in any form or by any electronic,
mechanical or other means, now known or hereafter invented,
including photocopying and recording, or in any information
storage or retrieval system, without the permission in writing
from the Publishers.

ISBN: 978 1 3981 0942 1 (print)
ISBN: 978 1 3981 0943 8 (ebook)

British Library Cataloguing in Publication Data.
A catalogue record for this book is available from the British Library.

Typeset in 10pt on 13pt Celeste.
Typesetting by SJmagic DESIGN SERVICES, India.
Printed in the UK.

Introduction

In the year 2000, Bass plc, at that time the largest company in the UK brewing industry, sold its brewing, brand-owning and beer wholesaling operation (Bass Brewers Ltd) to Interbrew S.A., a Belgian-based brewer that had developed global ambitions. This was in order that Bass plc (which subsequently changed its name, via Six Continents plc, to Intercontinental Hotels Group) could further extend and develop its interests in the international hospitality and leisure industry.

The government-enforced break-up and sale of Bass Brewers Ltd by Interbrew in 2001 brought to an end a brewing company that could trace its origins back to the late 1700s, and which during the nineteenth century had grown to become the largest ale brewer in the world.

Bass, the brand name, together with its iconic red triangle trademark, was renowned and respected among beer drinkers worldwide, and for over 150 years was the archetype of a particular style of beer: India Pale Ale (IPA). During the latter half of the nineteenth century, it was the huge demand for IPA – both in the UK and overseas – and the beer's close association with Burton-upon-Trent, that led to Burton becoming known as 'the brewing capital of the world'.

However, in the years preceding its demise, Bass Brewers Ltd, as a division of Bass plc, owned and operated a nationwide network of breweries producing a wide range of differing beer styles: lagers, ales and stouts, many of which were household names. This network was the result of a series of mergers and acquisitions within the UK brewing industry which began in the late 1950s, and took place against a background of growing industrial, economic and social change, as well as in response to developments specific to the UK brewing industry and beer market.

The mergers leading to the formation of Bass plc owed much to the personalities and ambitions of a few enterprising and determined individuals, who had both the vision and drive to create a company that was to become the dominant player in the UK brewing industry during the latter half of the twentieth century.

There are a number of distinct chapters to the story, which can be summarised as follows:

Bass, Ratcliff & Gretton: A Burton-based brewing company that in the 1800s developed and promoted a new style of beer, and in so doing created a brand name that became a byword for quality around the world and made the company (and town) a wonder of the Victorian era.

Mitchells & Butlers: A well-respected Birmingham brewer that, in order to broaden its reach, merged with Bass in 1961 to form Bass Mitchells & Butlers (BM&B), thereby aligning itself with nationally recognised brands and gaining access to a national distribution system.

Hope & Anchor Breweries Ltd: A small Sheffield brewery that in the 1950s provided a UK entry point for a Canadian brewing entrepreneur with ambitions of developing a national brewing group across the UK, capable of brewing and retailing national brands.

Hammond's Bradford Brewery Co. Ltd: A Yorkshire brewing company that from the mid-1940s onwards began to expand across the north of England through a programme of acquisitions and after joining forces with Hope & Anchor in 1960 (to form what became United Breweries Ltd), further extended its reach into Scotland, Wales and Northern Ireland.

Charrington & Co. Ltd: A long-established London brewer, this company had grown steadily through acquisitions across the south and west of England during the pre-and post-war years, and merged with United Breweries in 1962 to form Charrington United Breweries (CUB).

The merger in 1967 of BM&B with CUB to form Bass Charrington (subsequently renamed Bass plc) came at a time of immense social, industrial and economic change. However, the new company, in bringing together a pool of talent and expertise from across the UK, was well placed to meet the opportunities and challenges it now faced, and for the next thirty years it was the major force within the UK brewing industry.

A number of widely differing individuals and personalities were involved in driving all of the above. They ranged from men who became pillars of the brewing 'establishment' such as Michael Thomas Bass and Sir William Waters Butler, to others regarded more as mavericks and/or individualists such as Edward Plunket Taylor, Harry L. Bradfer-Lawrence, Tom Carter and H. Alan Walker.

There was nothing inevitable about the formation of Bass plc and, as becomes evident as the story unfolds, in reality a number of the steps leading to its formation depended as much on the interplay between the various personalities involved as on the more tangible business objectives.

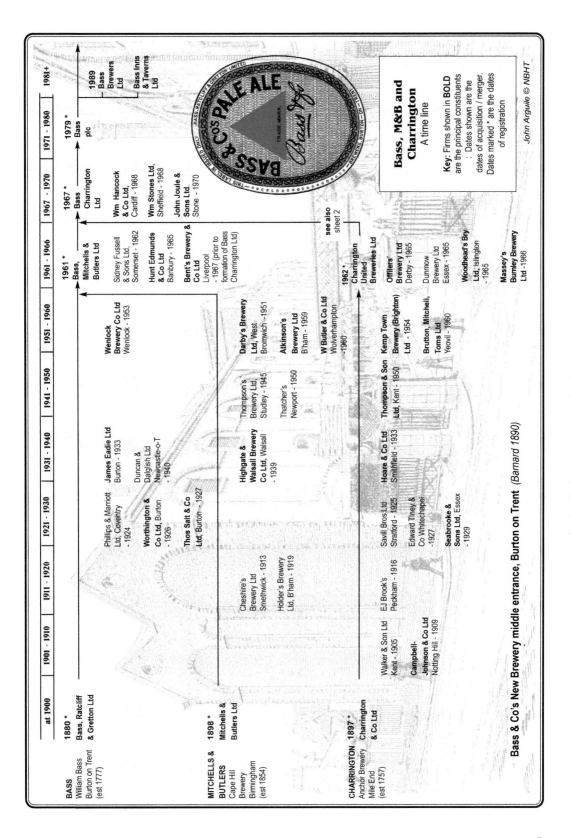

Bass, M&B and Charrington
A time line

Key: Firms shown in **BOLD** are the principal constituents : Dates shown are the dates of acquisition / merger. Dates marked * are the dates of registration

John Arguile © NBHT

Columns: at 1900 | 1901 - 1910 | 1911 - 1920 | 1921 - 1930 | 1931 - 1940 | 1941 - 1950 | 1951 - 1960 | 1961 - 1966 | 1967 - 1970 | 1971 - 1980 | 1981+

BASS
William Bass
Burton on Trent
(est 1777)

1880 *
Bass, Ratcliff & Gretton Ltd

MITCHELLS & BUTLERS
Cape Hill Brewery
Birmingham
(est 1854)

1898 *
Mitchells & Butlers Ltd

CHARRINGTON
Anchor Brewery
Mile End
(est 1757)

1897 *
Charrington & Co Ltd

Phillips & Marriott Ltd, Coventry - 1924
James Eadie Ltd Burton - 1933
Duncan & Dalglish Ltd Newcastle-o-T - 1940
Worthington & Co Ltd, Burton - 1926
Thos Salt & Co Ltd, Burton - 1927

Wenlock Brewery Co Ltd Wenlock - 1953

1961 *
Bass, Mitchells & Butlers Ltd

Sidney Fussell & Sons Ltd, Somerset - 1962
Hunt Edmunds & Co Ltd Banbury - 1965
Bent's Brewery & Co Ltd Liverpool - 1967 (prior to formation of Bass Charrington Ltd)

1967 *
Bass Charrington Ltd

Wm Hancock & Co Ltd, Cardiff - 1968
Wm Stones Ltd, Sheffield - 1968
John Joule & Sons Ltd Stone - 1970

1979 *
Bass plc

1989
Bass Brewers Ltd
Bass Inns & Taverns Ltd

Cheshire's Brewery Ltd Smethwick - 1913
Holder's Brewery Ltd, B'ham 1919
Highgate & Walsall Brewery Co Ltd, Walsall - 1939
Thompson's Brewery Ltd, Studley - 1945
Thatcher's Newport - 1950
Darby's Brewery Ltd, West Bromwich - 1951
Atkinson's Brewery Ltd B'ham - 1959
W Butler & Co Ltd Wolverhampton - 1960

Walker & Son Ltd Kent - 1905
Campbell-Johnson & Co Ltd Notting Hill 1909
EJ Brook's Peckham - 1916
Savill Bros Ltd Stratford - 1925
Edward Tiney & Co Whitechapel - 1927
Seabrooke & Sons Ltd, Essex - 1929
Hoare & Co Ltd Smithfield - 1933
Thompson & Son Ltd, Kent - 1950
Kemp Town Brewery (Brighton) Ltd - 1954
Brutton, Mitchell, Toms Ltd Yeovil - 1960

1962 *
Charrington United Breweries Ltd

Offilers' Brewery Ltd Derby - 1965
Dunmow Brewery Ltd Essex - 1965
Woodhead's Bry Ltd, Islington - 1965
Massey's Burnley Brewery Ltd - 1966

see also sheet 2

Bass & Co's New Brewery middle entrance, Burton on Trent *(Barnard 1890)*

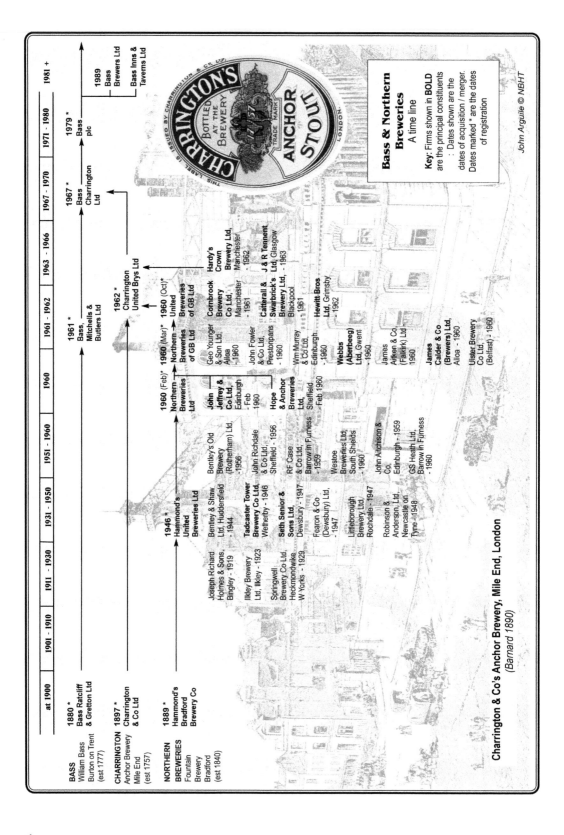

Bass & Northern Breweries — A time line

Charrington & Co's Anchor Brewery, Mile End, London
(Barnard 1890)

Bass, Ratcliff & Gretton Ltd

William Bass, the founder of the company, had built up a successful road haulage business before he moved to Burton and acquired land and property on the east side of High Street in 1777 in order to start a brewing business (when he was sixty).

Brewing was already a well-established trade in the town, with a number of Burton's brewers not only supplying local inn keepers, but also sending their beers as far as London and Manchester – a factor that may well have first brought them to the attention of Bass, since he operated a regular carriage service between the two cities.

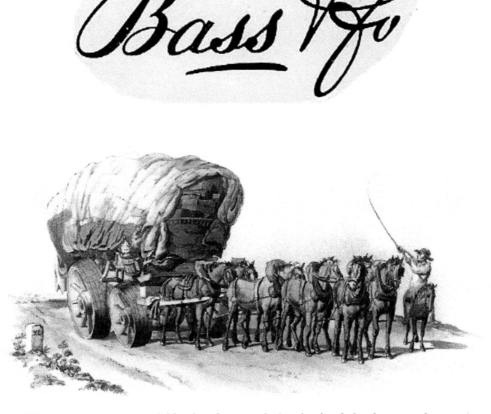

William Bass ran a successful haulage business before he decided to become a brewer. (*Wagon* by W. H. Pyne, Science Museum Group Collection)

There are recorded instances of 'Burton Ale' being sold (and enjoyed) in London as early as 1630, but even in the eighteenth century transporting beer over such distances was rare. In part this was due to the difficulties (and costs) associated with road haulage, but also because of the limited keeping properties of most beers.

However, in the late eighteenth century the brewing industry, in common with a number of other UK manufacturing industries, was on the cusp of change. The advent of the steam engine, together with the availability of measuring instruments such as the thermometer and hydrometer were leading to increased mechanisation, scale-up and control of what, outside of London, was still for the most part a cottage industry. The era of the 'brewing victualler' – publicans who brewed beer for consumption solely on their own premises – was increasingly being superseded by the 'common brewer', specialist commercial brewers who sold their beer on into the licensed trade.

Nothing is known of Bass's early brewing years, but it is likely that he followed the pattern already established by a number of other Burton brewers of supplying mainly distant markets; not only London but also a number of the Baltic ports ranging from Danzig as far as St Petersburg.

This so-called 'Baltic Trade' had developed following the opening of the Trent Navigation between Burton and Gainsborough in 1712. Burton's brewers (who in reality would be better described as mercantile brewers) worked in collaboration with merchants and shipowners in Hull to develop a system whereby their beers could be traded overseas for iron, timber, flax and hemp, commodities that were much in demand across the Midlands. Thus, right from those early days, the excellent keeping qualities of Burton's beers and their ability to travel long distances were recognised and exploited.

An eighteenth-century brewhouse. (National Brewery Centre)

Trent
Navigation Co.
barges in Hull.
(National
Brewery Centre)

The brig *Helen,*
a Baltic trader, at
Hull. (National
Brewery Centre)

On his death in 1788, William's son Michael followed him into the business and continued to develop markets for his beers, not just locally but also in London and the increasingly industrialised cities across the north of England, as well as overseas, through the ports of both Liverpool and Hull.

In 1791 Michael went into partnership with James Musgrave, who had inherited a brewery that was not only Burton's oldest (dating from 1708) but also had a well-established reputation in both home and overseas markets.

This association benefitted Bass, enabling him to gain a foothold in important markets. However, it was to be short-lived, and following its dissolution in 1797 Michael, now with

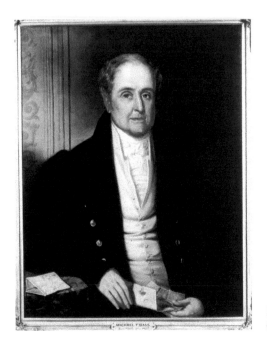

Michael Bass (1759–1827). (National Brewery Centre)

a new partner, John Ratcliff, suffered some initial setbacks. Nevertheless, Bass and Ratcliff persevered, although overall brewing volumes remained low: in 1800, after twenty-three years in the business, they were still brewing less than 3,000 barrels per year, a reflection in part of the difficulties in obtaining reliable agents as well as efficient, safe and secure distribution systems.

Their dual focus on home and overseas markets was to stand Bass & Ratcliff in good stead as the Napoleonic Wars of the late 1700s/early 1800s caused the Baltic trade to become increasingly fraught, until eventually it ceased altogether in 1807, resulting in the closure of a number of Burton's breweries – out of fourteen brewers in the town in 1780 only seven remained by 1806. (The Baltic trade was revived briefly in 1815 but finally collapsed in 1821 when Russia imposed a prohibitive tariff on all beer imports.)

Following the loss of the Baltic trade, Bass & Ratcliff made strenuous efforts to increase sales both locally across the east midlands, as well as in the established (and growing) markets of London and the northern industrial cities. Also, there is little doubt that a substantial proportion of their sales to Liverpool and London were destined for export to North America, the West Indies, Australia and other distant markets. This again illustrates the superb keeping qualities of Burton ale and its ability to withstand long sea voyages, thereby enabling Burton brewers to satisfy demands beyond the reach of most brewers elsewhere.

By 1820 Bass & Ratcliff had become one of (if not the) most dominant of the Burton brewers with an annual output of 7,500 barrels, and in the following years, together with other brewers in the town, they started to trial a new style of beer. This was much paler in colour than the hitherto nut-brown Burton ales, more heavily bittered, and intended for a new (and again distant) market: India.

Initially the India trade was dominated by a London brewer, Mark Hodgson, who, because of the preponderance of homeward-bound cargoes, was able to take advantage of very low export freight charges – much as the Burton brewers had done with the Baltic

trade. However, when at the request of the East India Company, Burton's brewers (notably Bass and Allsopp, another Burton brewer) started to reproduce Hodgson's ale, sales of their beers (which became known as India Pale Ale) steadily increased, the characteristics of Burton water enabling their beers to outmatch their London competitor. By 1832 sales of Bass's East India Pale Ale exceeded the combined volumes of Allsopp and Hodgson, and continued to dominate the India market thereafter.

On the death of Michael Bass in 1827, his son Michael Thomas Bass, who had been born in 1799 and joined the business in 1818, succeeded him. In 1835, following the death of his father John, Samuel Ratcliff was admitted as a partner together with John Gretton,

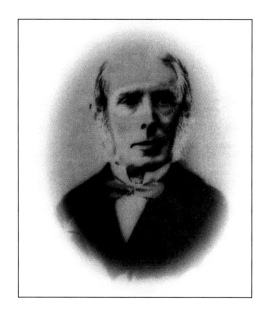

Right: Michael Thomas Bass provided overall leadership and direction.

Below left: Samuel Ratcliff, primarily responsible for financing and business organisation.

Below right: John Gretton had overall responsibility for the malting and brewing operations.

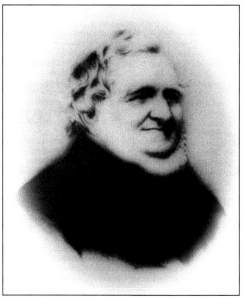

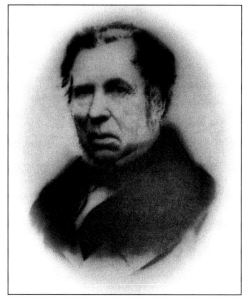

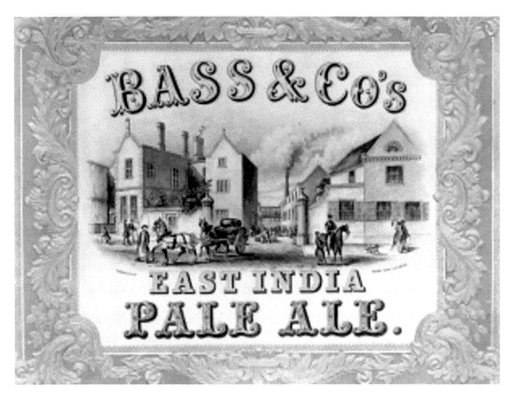

An early Bass showcard showing the entrance to the High Street Brewery, Burton, 1834. (National Brewery Centre)

who had joined the company in the early 1800s. Over the next forty years, it was to be this triumvirate of Bass, Ratcliff and Gretton who were to transform the company into the largest ale brewery in the world.

It has been said that the initial popularity of Bass's India Pale Ale in the Liverpool area stemmed from the sale of several casks of the beer by underwriters following a shipwreck in the Irish Sea in 1827. Be that as it may, following its introduction into home markets (principally London, the Midlands and Liverpool) demand for Bass's India Pale Ale steadily increased and, even before the advent of the railway network (which reached Burton in 1839), sales doubled (from approximately 10,000 barrels in 1829 to 22,000 barrels in 1837), much of this trade being supplied either via the Trent Navigation or the Trent and Mersey Canal – both slow, expensive and insecure means of transport.

The partners were therefore avid supporters of all schemes resulting in an improvement in the distribution network between Burton and potential markets. Consequently, they championed the rapid development of a national railway network, which enabled Bass and other Burton brewers to reach not just London, but also the rapidly growing manufacturing and mining towns of the north, the west midlands, and South Wales. With the Industrial Revolution now in full swing, a rapid growth in the urban population, together with a significant increase in real incomes, provided an almost limitless market for Burton's beers.

With the coming of the railways, Bass's annual sales volumes (approximately 75 per cent of which were pale ale) increased dramatically: from approximately 40,000 barrels in

Right: An early (1840s) Bass 'East India Pale Ale' label. (National Brewery Centre)

Below: Bass's 'New' Brewery yard, 1860s. (National Brewery Centre)

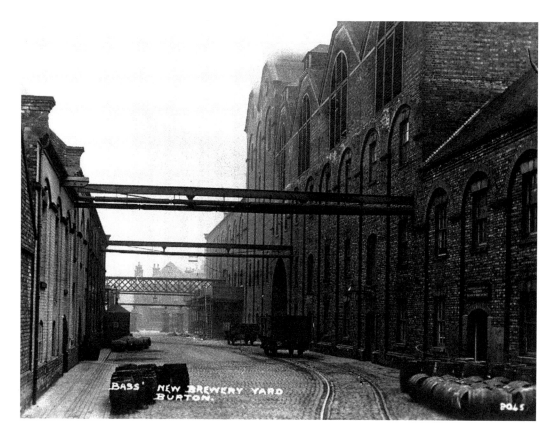

1843 to 148,000 barrels in 1853, when a second brewery (subsequently called 'the middle brewery') was built. Over the next decade annual volumes rose to 380,000 barrels, and in 1863 a third (the 'new') brewery was built.

Output continued to climb, reaching 600,000 barrels per year by 1870, before accelerating to 900,000 barrels per year in 1876, when work commenced to demolish the original brewery (now almost 100 years old) and completely rebuild it.

Left: The coppers on full boil at the 'New' brewery. (National Brewery Centre)

Below: The 'Old' Bass Brewery in High Street, Burton, viewed from The Hay. (National Brewery Centre)

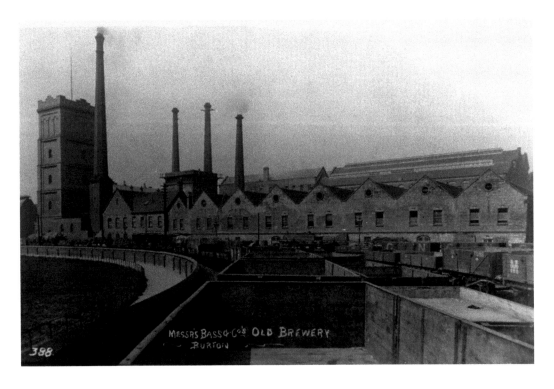

Mash Tuns in the 'Old' Brewery, after it was rebuilt in 1876. (National Brewery Centre)

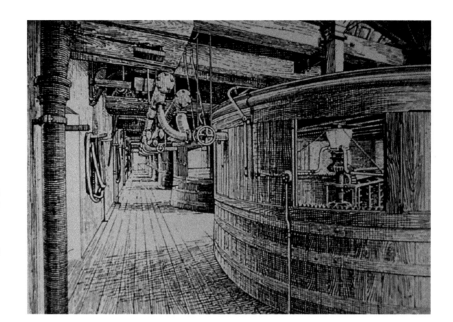

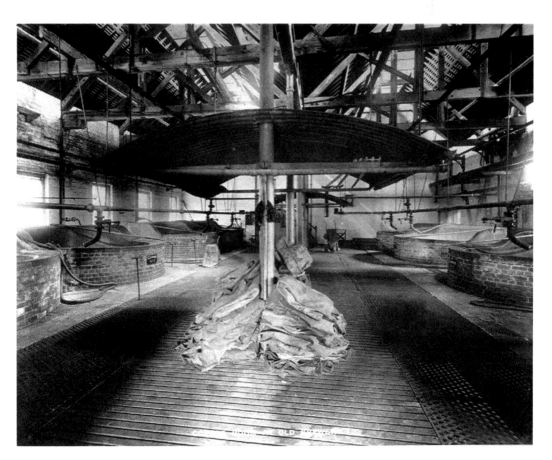

The Copper Hearth in the 'Old' Brewery after it was rebuilt in 1876. (National Brewery Centre)

By now Bass was the largest ale brewer in the world, and perhaps the best-known firm in the British Empire (described in 1879 as 'a mercantile Colossus ... a monument to the energy of men') employing in excess of 2,500 men and boys in 1887. Its three breweries and thirty-seven malt houses in Burton (with more in Lincoln and Retford) occupied around 150 acres, and by 1890 were all linked together by eleven locomotives operating over 17 miles of privately owned railway track. (The last steam locomotive was not withdrawn from service until 1964, when the entire rail network was finally closed due to mounting costs and its incompatibility with the changed site layout).

Bass's growth was based primarily on the quality and consistency of its beers, Burton pale ale selling itself not only on its strength and flavour, but more especially on its light, clear and sparkling appearance, qualities which were no doubt enhanced by the increasing popularity of bottled beer for the home trade, and the increased use of glass to replace pewter tankards and 'pots' in public houses. Bass, together with Allsopp, stimulated the

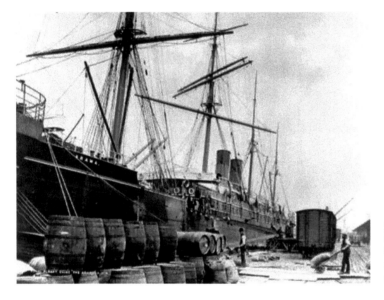

A steamship being loaded with beer at Liverpool Docks. (National Brewery Centre)

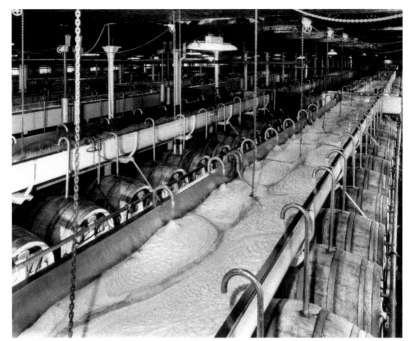

Beer fermenting in Union Sets in Bass's 'Old' Brewery. The union system of fermentation was first trialled by John Gretton around 1840 and became synonymous with Burton-on-Trent. (National Brewery Centre)

'The Beer of the Empire'. (National Brewery Centre)

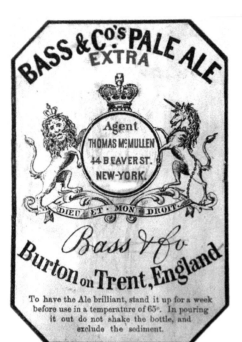

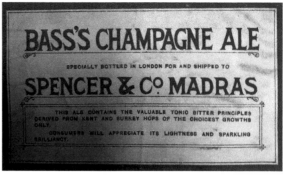

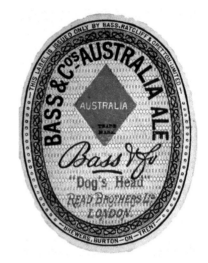

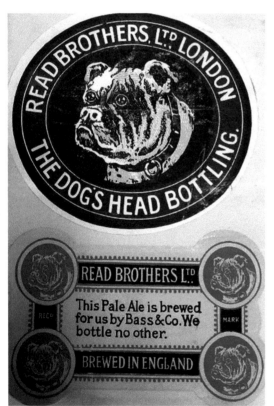

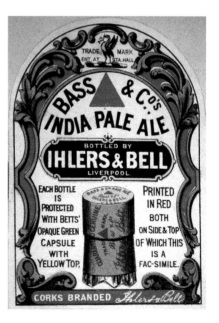

A selection of labels used by export bottlers and agents. (National Brewery Centre)

Originally a shipping mark, the Bass red triangle was first used in 1855, and became the world's first registered trademark in 1876. (National Brewery Centre)

demand for Burton pale ale and then exploited it to the full, creating what was in effect a revolution in popular taste.

For distribution and marketing both Bass and Allsopp relied on a national network of independent wholesale bottling firms (and in smaller, more remote locations, wine and spirit merchants and local brewers). These wholesalers acted as the brewers' agents in the major population centres, receiving their beer in bulk by rail from Burton and bottling it for distribution to the retail trade. The goodwill of these local firms was essential since, at least until the late 1880s, neither of the two major Burton brewers owned public houses, and so relied heavily on the support of licensed victuallers and beerhouse keepers. Wholesalers were therefore allowed generous profit margins, which encouraged them to push and promote Burton beers in the retail trade.

This free market approach to sales and marketing was also reflected in the emphasis Bass and Allsopp placed on their respective trademarks – aiming to impress their brand image on the mind of the beer drinker, so he would instantly recognise the Bass red triangle or Allsopp's red hand and associate them with top quality.

This strategy was remarkably successful, but by 1890 the era of Burton's supremacy was coming to an end – in part because other brewers were beginning to produce their own 'Burton-type' pale ale, scientific understanding and technical improvements in the brewing process having eroded some of the mystique surrounding Burton's supremacy.

However, a more direct cause of the fall-off in volume of Burton's beers was that increasingly across the UK, local brewers began to take direct control over more and more licensed houses in order to promote and sell their own beers. This growth of the

Left: Bass pioneered brand marketing: the red triangle became an internationally recognised symbol of a top-quality beer. (Neil Buxton personal collection)

Below: *The Public Bar* by J. Henry Henshall (1856–1928). (Christopher Wood Gallery, London)

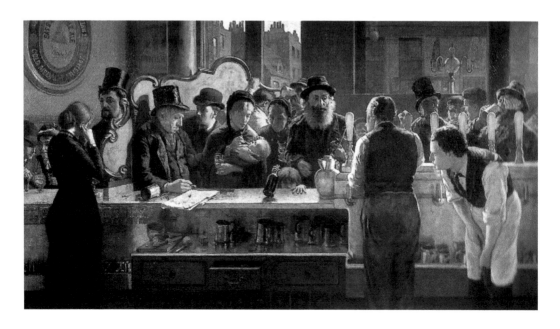

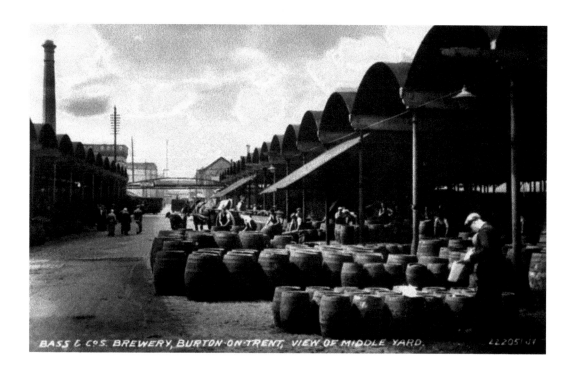

BASS & Cº S. BREWERY, BURTON·ON·TRENT, VIEW OF MIDDLE YARD.

Above: Cask-washing sheds, Bass's Middle Yard, Burton. (National Brewery Centre)

Right: Pyramids of casks at Bass's Dixie Sidings, Burton. (National Brewery Centre)

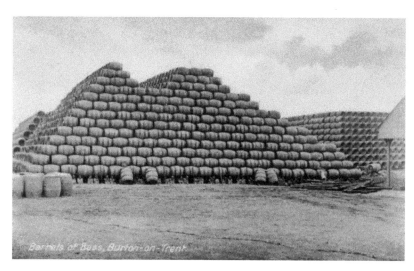

so-called 'tied trade' was in large part initiated by government legislation, in 1869 and 1872, restricting the granting of new licences. This was in an attempt to control problems associated with excessive drinking, as well as in response to the growing influence of temperance and prohibitionist organisations – a factor that was to increase significantly in importance in the years to come.

Another factor influencing the growth in tied trade was that after 1876, for the first time in over three decades, there was a decline in overall beer consumption, which was to continue to stagnate for the next twenty years. This left many brewers with spare capacity

and increased production costs and led a number of them to safeguard their sales by acquiring the freehold or leasehold of as many licensed premises as they could within their own localities.

Bass also entered the property market, albeit reluctantly and late in the day, initially preferring the 'loan-tie' arrangement between brewer and publican over the more formal tie of landlord and tenant. However, Bass still regarded themselves predominantly as suppliers of quality beers to all licensees, tied as well as free, and believed that sales of their beer would somehow transcend the tied-house system.

By 1890, approximately 70 per cent of the 102,000 pubs and beerhouses in England and Wales were tied, mainly by direct brewery ownership of the freehold or leasehold, and over the next few years there was a scramble to buy up the remaining free houses. This came at a time when many brewing companies were reconstituting themselves from private to public limited liability companies (Bass became a plc in 1888), a move which proved extremely popular with investors large and small, thereby providing additional resources for the purchase of licensed property. This competition for licensed properties resulted in an inflationary boom in prices, which was to have important consequences for the industry in the years that followed.

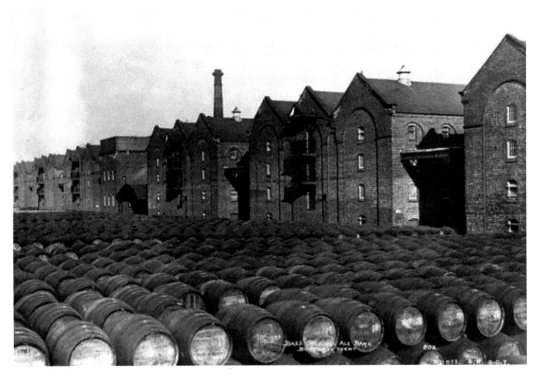

The Shobnall Maltings complex on the outskirts of Burton, built between 1873 and 1876. (National Brewery Centre)

Throughout all these decades of intense growth, during which Bass was transformed from a modest provincial brewery into a world-ranking business, the company was led by Michael Thomas Bass, who, in addition to becoming an industrial tycoon and a country landowner, also played an active role in Parliament (he was first elected MP for Derby in 1848 and represented the constituency for thirty-three years).

Within Parliament Bass remained loyal to the Liberal cause despite its sympathetic attitude towards the temperance movement, and he frequently clashed with Gladstone, who nevertheless held Bass in the highest regard, and described his company as 'a permanent and respected institution of the country'.

M. T. Bass was particularly renowned for his efforts to raise the living standards of the working class and, as an important customer as well as shareholder of the Midland Railway, he was well placed to support his constituents in Derby, many of whom were railway employees, in their fight for better working conditions.

Within the local community, M. T. Bass was unequalled as a public benefactor, constructing and endowing many public buildings in both Burton and Derby. He declined the offer of a peerage on several occasions, and on his death in 1884 was succeeded as chairman of the company by his son Michael Arthur Bass, who had joined the company in 1863.

Like his father, M. A. Bass was a Liberal MP, first elected to represent Stafford in 1865, but later transferring to the East Staffordshire constituency, and becoming Burton's first

Above left: Michael Thomas Bass (1799–1884). (National Brewery Centre)

Above right: Michael Arthur Bass (1837–1909), the first Lord Burton. (National Brewery Centre)

MP in 1885. Soon afterwards he was raised to the peerage as Baron Burton. The Liberal party's increasingly strong support for the temperance movement and its commitment to a reduction in the number of licensed premises eventually led Lord Burton to leave it (in 1894) and to join the Unionists.

Post-1900 the economy went into recession and overall beer volumes again declined, a situation not helped by increased taxes, a continuing restriction and reduction in the number of licensed premises, and growing evidence of a change in public attitudes towards the consumption of alcoholic drinks – the vociferous campaign by the temperance movement doubtless contributing to this effect. In short, the public were beginning to spend more of their money on other things.

Despite this hostile environment, under the chairmanship of M. A. Bass the company continued to make progress, seeing its annual output increase from 915,000 barrels in 1889 to 1,440,000 barrels in 1901, production now greatly facilitated by the ability to brew all-year round.

The death of M. A. Bass in 1909 ended the Bass family connection with the company after four generations. Lord Burton had been a much respected man, who had expended great efforts on behalf of the company, the brewing industry as a whole, and the town of Burton. Like his father, he believed in developing working conditions that were both effective and reasonable, and in providing housing and recreational facilities for the company's employees, which were the envy of most other industrial workers.

The role of chairman now passed to John Gretton III, who had been appointed to the board sixteen years earlier and, in his capacity as Unionist MP for South Derbyshire, was well placed to counter the attacks of temperance supporters both locally and in Parliament.

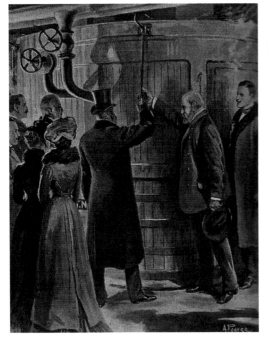

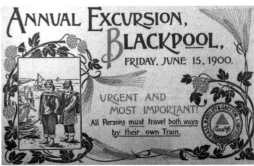

Above: A ticket for a Bass Annual Excursion. These were held between 1889 and 1914, rotating on a four-year cycle between Liverpool, Blackpool, Yarmouth and Scarborough. (National Brewery Centre)

Left: King Edward VII, assisted by the Bass Head Brewer Cornelius O'Sullivan, FRS, opens the malt hoppers to start a special brew – the King's Ale – on 22 February 1902. (National Brewery Centre)

Regional ale stores and offices of Bass Agencies, *c.* 1900. (National Brewery Centre)

John Gretton III (1867–1947), the first Lord Gretton. (National Brewery Centre)

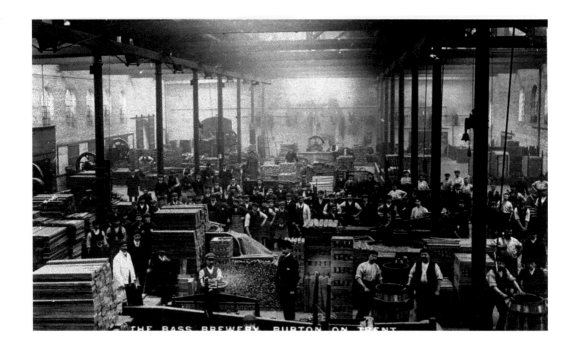

THE BASS BREWERY BURTON ON TRENT

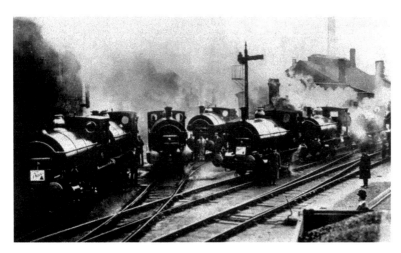

Above: Bass's Steam Cooperage, *c.* 1900. (National Brewery Centre)

Left: Steam locomotives in the Burton brewery, *c.* 1912. (National Brewery Centre)

During the First World War the government placed increasingly onerous restrictions on the brewing industry, principally by means of a series of huge increases in the duty rate combined with dramatic reductions in public house opening hours – restrictions which were maintained when the war ended. The net result was that the consumption of beer fell sharply (from a national output of approximately 36 million barrels in 1914 to less than 14 million barrels in 1918) – as did its strength.

Post-war economic depression and high unemployment levels, coupled with the high price of beer, saw beer consumption fall again. Changes in social behaviour and attitudes towards drink were now beginning to play a significant role, fuelled in part by a proliferation in alternative leisure time activities (particularly radio and the cinema).

Alternative label designs for reduced strength wartime beer – never used. (National Brewery Centre)

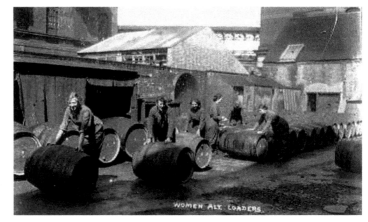

Women brewery workers during the First World War. (National Brewery Centre)

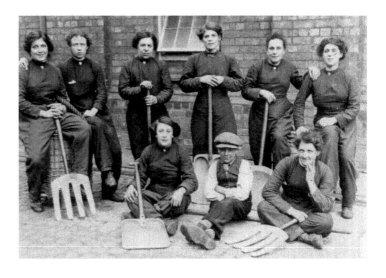

Women maltings workers outside a Bass floor maltings, 1917. (National Brewery Centre)

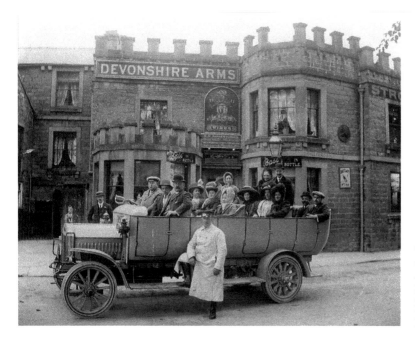

Charabanc outings were popular with pub goers in the 1920s. (National Brewery Centre)

The net result was that fewer people were going into public houses, and once there they were drinking less.

In an era of weaker beers the Burton brewers, who had always been known for the strength and bitterness of their beers, found themselves at a disadvantage. Because Bass still regarded themselves primarily as brewers rather than property owners, the company relied heavily on its national network of agencies (during the 1920s less than 10 per cent of the company's annual volume was sold through its own houses). It was therefore extremely dependent on the willingness of other brewers to carry its draught and bottled beers.

However, despite having the financial resources to do so, Bass seems to have been reluctant to underpin its dependency on the free trade by acquiring other brewing companies, the prevailing view appearing to be that smaller brewers would continue to sell Bass's beers due to customer demand.

Moreover, during this period (the early 1920s), the company's overall brewing volumes had climbed back up to their pre-war levels (approximately 1.2 million barrels), although they went into a slow decline thereafter.

Despite an apparent lack of any decisive policy to increase sales and/or improve production efficiencies, during this period Bass did take minority holdings in Wilson's Brewery in Manchester and in the Wenlock Brewery in London (which eventually became a wholly owned subsidiary in 1954). Then, in 1926 the company merged with its long-standing Burton arch-rival: Worthington.

Similar to William Bass, the first William Worthington had moved to Burton from Leicestershire. In 1744, aged twenty-one, he worked in one of the town's breweries as a cooper, but in 1760 he purchased the brewery and became one of Burton's merchant brewers supplying the Baltic trade. His two sons both married daughters of another Burton brewer, Henry Evans, who at the time of their marriages gave his daughters a

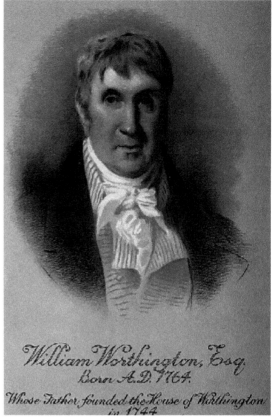

Above: The company traded as Worthington & Robinson from the 1830s to 1862. (National Brewery Centre)

Right: William Worthington II (1764–1825), son of the original founder. (National Brewery Centre)

William Worthington, Esq.
Born A.D. 1764.
Whose Father founded the House of Worthington in 1744

well-established brewery in the High Street, thereby significantly enhancing the brewing prospects of the Worthington family.

Following the end of the Baltic trade in the late 1820s Worthington developed and marketed its own India Pale Ale.

From the 1860s onwards Worthington & Co. pioneered the development and application of brewing science and were the first brewers in the world to include laboratory analysis in a systematic manner as part of the brewing process. They employed a chemist, Horace Tabberer Brown, who was to become world famous for his work on the isolation and cultivation of pure strains of brewing yeast.

By the 1880s Worthington's had become the third largest of the Burton brewers (behind Bass and Allsopp), and had acquired a national reputation for the quality of its bottled pale ales.

Following the death of the fourth and last member of the Worthington family, William Henry Worthington, in 1894, William Posnette Manners, who had joined the company as an office boy in 1862 and had been appointed a director in 1889, now became deputy chairman and MD. Under his astute (to which some would add ruthless and autocratic) management, the company made significant progress in increasing its market share during the first decade of the twentieth century. On his death in 1915, control passed to his two sons: Arthur and Ernest.

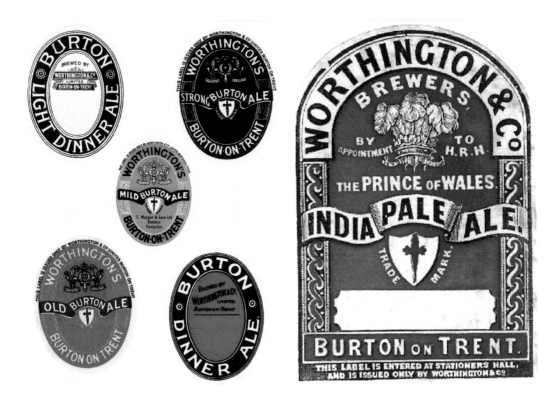

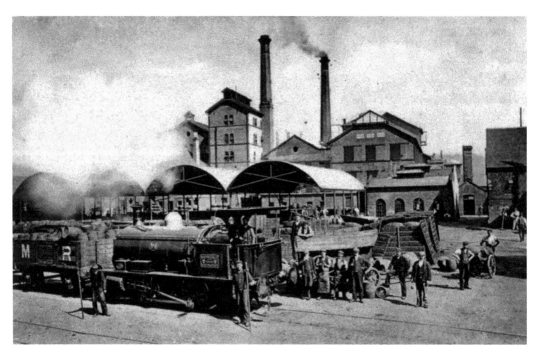

Above and opposite above: Two views of Worthington's Brewery, High Street, Burton: the first looking east towards the High Street, the second picture looking west away from the High Street showing the loading-out dock, 1880. (National Brewery Centre)

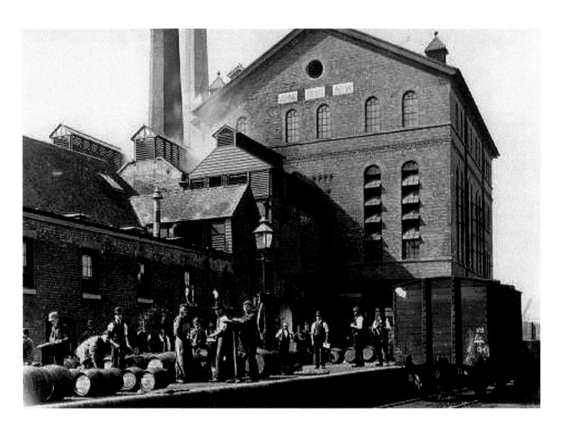

Above left: William Posnette Manners (1846–1915). (National Brewery Centre)

Above right: Arthur Manners (1890–1968). (National Brewery Centre)

It was Arthur Manners who initiated and drove the merger with Bass – a mutual desire for improved efficiencies providing the rationale as well as overcoming any personal animosities between the two companies (which existed at all levels of both organisations).

The chairman of Bass at the time was still John (now Colonel Sir John and later Lord) Gretton, and the terms of the agreement were such that, although Worthington was much the smaller of the two companies (capitalised at less than half that of Bass), after the merger Arthur Manners, as well as becoming chairman and joint MD of Worthington, also became deputy chairman and joint MD of Bass. Thereafter the Manners family largely supplied the directors of both companies.

The merger offered considerable potential benefits to both companies in terms of shared agency networks and licensed houses, rationalisation of brewing sites and operations, as well as joint purchasing and distribution operations. However, in reality the merger had little impact on the way in which either company was run, and the so-called amalgamation between Bass and Worthington never really happened, the two companies continuing to operate independently of one another.

In 1927 the new Bass board was immediately occupied with the purchase of Thomas Salt & Co., a Burton brewer almost as old as Bass itself, which during the nineteenth century had grown to become the town's fourth largest brewer and had built up a sizeable estate of licensed premises (the main reason for Bass's interest). However, due to a combination of fierce competition and poor management, Salt's had been in financial difficulties since the early 1900s.

In 1930 Britain felt the first impact of the Great Depression, and the brewing industry, especially in the older industrial areas, was badly affected. A combination of high unemployment, falling wages, and successive duty increases had dramatic effects on beer consumption (Bass's volumes falling from approximately 1 million barrels per year in 1929 to 720,000 barrels per year in 1932) and output did not recover until the end of the decade.

In 1933 another long-established Burton brewer, James Eadie & Co., was acquired, providing Bass with further valuable retail outlets (the Eadie brewery was immediately closed).

Also at this time (1934), Bass reacted to changes in public tastes by introducing Blue Triangle Bass in bottle as a 'bright' (filtered and pasteurised) alternative to the traditional bottle-conditioned Red Triangle, and saw a steady increase in sales.

 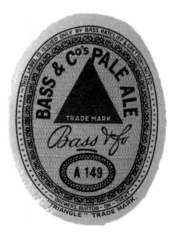

Above, right and below:
1920s/30s Bass adverts and
seaside postcards. (National
Brewery Centre)

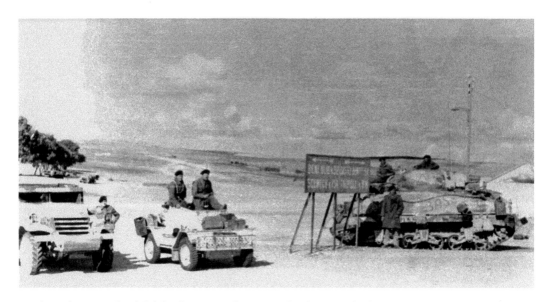

Product placement/wishful thinking: a tank crew in the desert with the Staffordshire Yeomanry during the Second World War. (National Brewery Centre)

During the Second World War, the government again used the brewing industry as a source of revenue, and beer duty was increased. However, output also increased (despite a reduction in gravities) and the industry's relationship with the government was far more positive than during the First World War.

In 1945, following a lengthy dispute with Arthur Manners, Lord Gretton tendered his resignation as chairman and was succeeded by Arthur Manners. In addition to being an MP during the long years of temperance opposition and government restrictions, as well as the owner of a large country estate, Lord Gretton had been an active member of the board for almost fifty-two years, and had served the company well. However, he lacked the authority of M. T. Bass and Lord Burton and, as events proved both at the time of the merger with Worthington and at the time of his retirement, he was no match for Arthur Manners.

Any thoughts that the end of the war would lead to a period of prosperity for the brewing industry were quickly dispelled, and from 1946 onwards overall UK beer volumes went into decline, reducing by 27 per cent to approximately 24 million barrels between 1946 and 1959. This fall was driven in part by high duty rates, but also by continuing changes in social attitudes towards drink and public houses, many of which, due to wartime restrictions, were now showing signs of neglect – despite the fact that for many brewers, they were their most valuable asset.

Growing consumer preferences for drinking bottled (and canned) beers at home and for keg (brewery-conditioned) beer as opposed to traditional draught beer in pubs were becoming increasingly evident – both developments that required investment in new equipment and changes in operating practices. Brewers were therefore now required to compete in a changing as well as a shrinking market.

Within Bass, annual output remained at around 1 million barrels throughout the 1950s (as it had during the war years), an overall performance that doubtless contributed

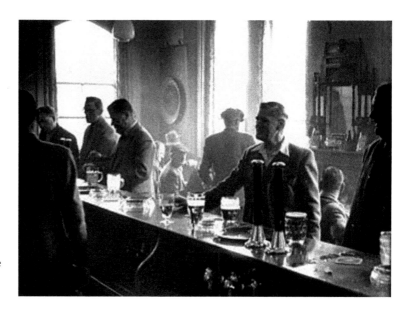

A public bar in the 1950s. (National Brewery Centre)

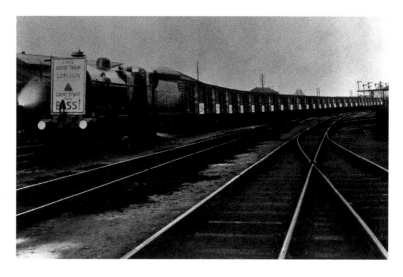

An 'ale train' leaving Burton for London – still a regular service during the 1950s. A 'Scotch Special' also departed three times a week, via Leeds and Carlisle. (National Brewery Centre)

towards a lack of urgency and a cautious approach (if not outright resistance) to change at board level.

There was still no agreed or comprehensive plan for the company's restructuring and rationalisation following the merger with Worthington, despite the wide geographic spread of the company's premises across Burton, rising production costs, duplication in processes and systems, and an outmoded (internal and external) transport system.

The growing popularity of bottled beers led to some new investment, but it was the declining popularity of its own beers compared with Worthington's that was of most concern – in 1958 sales of Bass beers for the first time fell below those of Worthington, a trend which was to continue. However, there was no agreement as to the cause(s) of this and a reluctance to make any changes to address it, a complacency doubtless encouraged

by the fact that group (i.e. Bass and Worthington) combined sales between 1953 and 1961 remained fairly constant at approximately 1.4 million barrels per year.

As the 1950s progressed it became increasingly apparent that Bass's performance in the marketplace no longer matched that of its rivals. Although its claims to be a national brewer remained valid, by the end of the decade its trading position in some areas of the country was being rapidly undermined. With 70 per cent of its sales still coming from the free trade, the company was heavily reliant on the willingness of small local brewers to carry Bass and Worthington as their national beers, which in turn was dependent on public demand.

However, with the exception of Worthington 'E' (Worthington's India Pale Ale), the company's beers now had an old-fashioned image and were losing ground in an increasingly aggressive and competitive market. Also, a significant number of Bass's customers in the small brewery sector found themselves being absorbed by larger companies who, for various reasons, did not carry Bass or Worthington.

In 1953, at the instigation of various city interests/institutional shareholders, Sir Peter James Grigg was appointed to the Bass board. Aged sixty-three, Sir James was a person of tremendous ability and standing, with a wealth of experience in politics and public service,

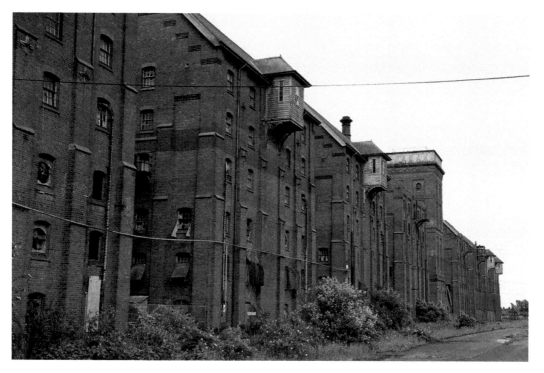

The Bass Maltings at Sleaford in Lincolnshire ceased production in the late 1950s. They were designed and built between 1903 and 1906 by Herbert A. Couchman, Bass's chief engineer. With their 1,000-ft frontage it has been said 'for sheer impressiveness little in English industrial architecture can equal the scale of these buildings'. (National Brewery Centre)

including a period as Secretary of State for War in Churchill's wartime cabinet. (He also had a reputation for being a tough, haughty and opinionated man, of whom Churchill is reported to have said, 'If only Grigg would treat me as an equal, I wouldn't mind.')

Arthur Manners resigned as chairman and as a director of the company that summer, and was replaced as chairman by C. A. Ball, who had been a Worthington board director since 1915 and was now aged sixty-five.

The Wenlock Brewery Co. finally became a wholly owned subsidiary of Bass in 1954, but the firm of Wilson & Walker, with which Bass had had a successful trading agreement for over fifty years, was allowed to slip away when Watney Mann decided to acquire it in 1959 – despite the fact that a significant portion of Bass's trade in the Manchester area took place through Wilson's houses.

A complacent and ultra-cautious approach was also reflected in the company's negative attitude towards its own tied estate, which until the late 1950s had as little money spent on it as possible.

Following the death of C. A. Ball in 1959, Sir James Grigg was appointed as his successor and, given the sudden marked increase in mergers and takeovers starting to occur within the brewing industry at that time, Grigg immediately turned his attention to the problems and possibilities of merging Bass with another brewing company. So, when in 1961, he was approached by the recently appointed CEO of Mitchells & Butlers Ltd, Grigg was receptive to what was proposed.

Left: Sir James Grigg (1890–1964).
(National Brewery Centre)

Below: The undercroft at
St Pancras station, 1958,
showing ale deliveries from
Burton being unloaded.
(Courtesy of the Science and
Society Picture Library/National
Railway Museum)

Mitchells & Butlers Ltd (M&B)

Mitchells & Butlers Ltd was the result of a merger between two Birmingham brewers: Henry Mitchell, who had started out as a publican brewer in 1866, brewing behind The Crown in Smethwick (which his father owned), and William Butler, another publican brewer, who had bought The Crown in Broad Street in 1883 and built a brewery behind

Below left: Henry Mitchell (1837–1914). (National Brewery Centre)

Below right: William Butler (1843–1907). (National Brewery Centre)

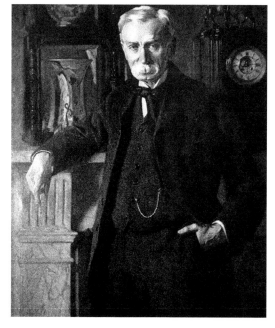

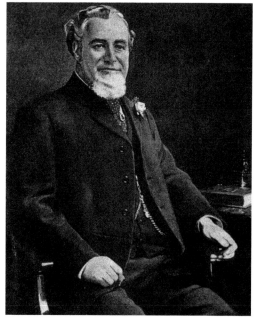

it capable of supplying not only The Crown but other publicans. Both men saw the benefits of building up an estate of brewery-owned public houses, and they joined forces in 1898, basing their new company at the Cape Hill brewery, which Mitchell had built in 1878.

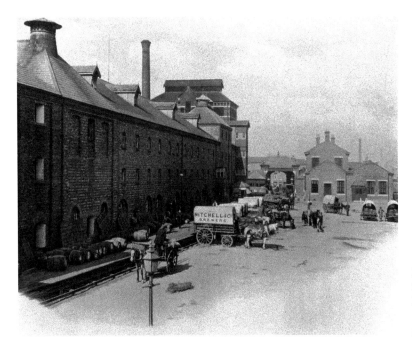

Henry Mitchell's Cape Hill Brewery, c. 1885 (National Brewery Centre)

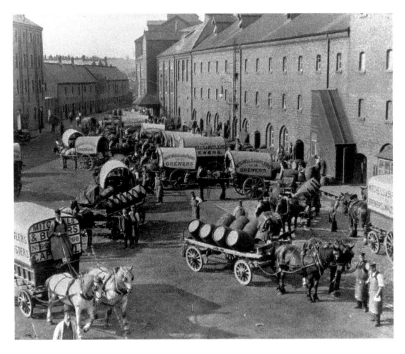

Mitchells & Butlers Cape Hill Brewery in 1902, with floaters and drays ready to depart. (National Brewery Centre)

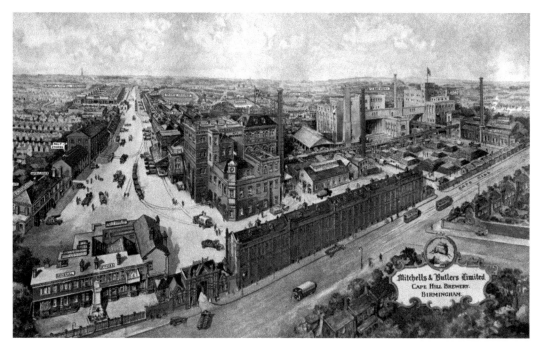

A view of Cape Hill Brewery in the 1920s. (National Brewery Centre)

Although both men had widely differing personalities (Mitchell being the more ascetic of the two and more production-focussed, Butler the more outgoing, and involved in various local charitable societies), they shared common aims: to brew good beer and to provide good pubs in which to enjoy it (as well as to make money).

By following this simple philosophy, Mitchell and Butler achieved instant success, and by the outbreak of the First World War were employing over 1,000 people on the Cape Hill site, which had been increased to 90 acres and, since 1912, now housed two breweries. During this period they also acquired three competitor Birmingham brewing companies.

From 1914 to 1939 the chairman of the company was William Waters Butler, the son of the original founder, who had first joined the board at its inauguration in 1898 (when apparently he had been instrumental in encouraging his father to join forces with Mitchell).

During the First World War Waters Butler was asked to become a member of the government's Central Control Board, established to exercise control over all aspects of the production, distribution and sale of alcoholic liquors – an indication of his and M&B's standing within the brewing industry.

From its early days, and in contrast to Bass, M&B had built up a significant estate of public houses. In the early 1920s the company owned 1,300 licensed premises, 60 per cent of which were run by salaried managers (as opposed to independent tenants). The company was therefore acutely aware of the importance of maintaining positive relationships with the licensing authorities within its various trading regions, and during the 1920s/30s, under Waters Butler's stewardship, M&B pioneered what became an industry-wide move to improve public houses – adopting the slogan 'Fewer and Better'.

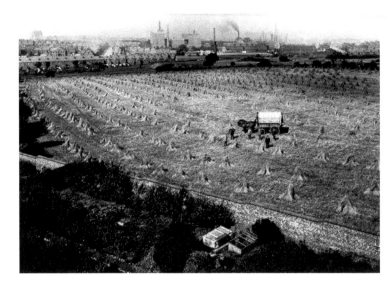

Barley being harvested from a field near Cape Hill in 1917. The brewery is visible in the background. (National Brewery Centre)

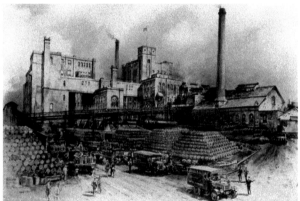

Above: Cape Hill No. 2 Brewery in the 1920s. (National Brewery Centre)

Left: William Waters Butler (1866–1939). (National Brewery Centre)

The intention was to broaden the appeal of licensed premises and to change public perceptions of them (as primarily men-only drinking dens) at a time of changing social attitudes. This policy was a slow and costly process, often hindered by the hostility of teetotal magistrates (and some customers) towards any moves that involved making public houses more attractive. However, the progress made by M&B in implementing this policy in the 1920s–30s had a far-reaching impact on the licensed trade as a whole, and helped its long climb back to 'respectability'.

Like his father, Waters Butler was a generous benefactor to numerous charities and educational/scientific institutions in and around Birmingham. He was particularly associated with the University of Birmingham, and played an important role in founding

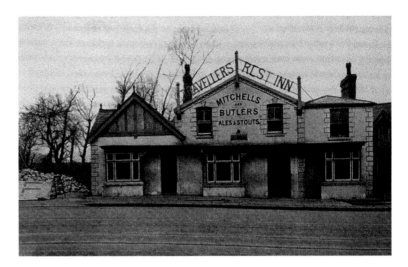

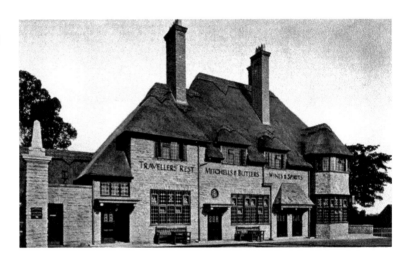

The Traveller's Rest, Northfield, before and after its rebuilding by M&B in 1929 – one of many such rebuilds. (National Brewery Centre)

the School of Malting & Brewing Science there. He was knighted in 1926 and died in 1939, and during his years as chairman M&B became one of the largest and most successful companies in the brewing industry.

As has been noted with Bass, the late 1930s saw a resurgence in beer drinking and a significant increase in bottled beers, which was also reflected in M&B's sales.

In 1939 M&B acquired the Highgate-Walsall Brewery Co. Ltd, which included an estate of pubs in the Walsall area, and contrary to normal practice kept the brewery in full production because of the popularity of its dark mild ale in the Walsall area.

By the end of 1945 Cape Hill's annual production was 960,000 barrels, 77 per cent of which was sold through its tied estate of approximately 900 pubs (cf. Bass), but by 1955 production had eased to less than 800,000 barrels per year.

In the post-war years, as the redevelopment of Birmingham city centre got underway (entailing the loss of a number of public houses), M&B extended into new areas. In 1950 they acquired Thatcher's Brewery of Newport, providing a springboard into Wales, and in

Left and above: 1930s bottle labels and advertising display card. (National Brewery Centre)

1951 M&B acquired (by invitation) Darby's Brewery of West Bromwich, a small family firm with ninety-five licensed houses.

By the mid-1950s M&B was recognised as one of the largest and most financially sound brewing companies in the UK, with a national reputation as a safe investment and for professional, albeit rather staid, management. However, the company still had only a regional trading position.

In 1956 the M&B board, at the behest of their merchant bankers, appointed H. Alan Walker as chief executive director, a man with no previous experience in the brewing

H. Alan Walker (1911–78).
(National Brewery Centre)

industry, and whose career to date had been confined to the sugar industry, principally with Tate & Lyle Ltd and its subsidiary United Molasses Co. Ltd.

While working for these companies, Walker had travelled the world, and had spent a significant period of time in the tropics managing a sugar plantation. Within four years Walker completely revitalised M&B, turning it into an efficient, expanding and increasingly profitable company. Output and productivity were significantly increased, and Walker changed the company from being inward looking and production-led to one more focussed on sales and marketing. He also expanded M&B's presence in the growing free trade.

In 1959 M&B acquired Atkinson's Brewery Co. Ltd in Aston (with 360 licensed houses), quickly followed by W. Butler & Co. Ltd of Wolverhampton, who had 830 licensed houses spread across the heavily industrialised areas of the Midlands, and whose mainstay product was Springfield Bitter.

However, M&B was still not large enough to protect itself from a potential takeover and so, in 1961, Walker decided to make the critical leap from regional to national trading status, and the partner he chose was Bass, Ratcliff & Gretton Ltd.

Walker's interest in Bass stemmed from the fact that there was still an enormous amount of goodwill behind their beers: the names Bass and Worthington were household names synonymous with first-class beer. Walker also valued Bass for its national trading network, with seventeen subsidiary companies stretching from Plymouth to Newcastle. Moreover, Bass had huge financial resources and, unlike many of its rivals, was not burdened by a number of small, loss-making tenancies. Bass also retained an amazing amount of loyalty from employees at every level of the organisation, albeit a number liked to think of themselves as working for the 'Rolls-Royce' of the brewing industry, which in terms of their beers was probably correct. The scope for renewed growth was therefore self-evident.

When Walker approached Sir James Grigg and made it clear that Grigg could retain the chairmanship of the new group so long as he, Walker, became chief executive, there was no obstacle to the merger, which was formally announced in July 1961.

Bass, Mitchells & Butlers Ltd (BM&B)

In the first two years of the new company's formation both the Atkinson brewery in Aston and the Wenlock brewery in London were closed, and production centred on Burton and Birmingham. Following the death of Sir James Grigg in 1964, Alan Walker became chairman as well as chief executive, and a strategy of decentralisation with respect to sales and marketing was adopted, with six regional operating companies being established.

One factor that undoubtedly assisted the newly formed company was a renewed growth in the drinks market in the early 1960s. This was stimulated in part by a relaxation in the licensing laws in 1961, as well as by an expansion of the free-trade (in particular clubs, restaurants and off-licences), both these factors being accompanied by a steady rise in the standard of living and the emergence of a new generation of drinker.

During this period there was also a decisive swing towards keg (brewery-conditioned) beer and, increasingly, lager. As well as being far easier for licensees to handle and serve, keg beer was easier to transport over long distances, had a superior shelf life, and was far more consistent in flavour and appearance than traditional draught beer. It therefore leant itself to the production, distribution and marketing of beer on a national scale.

At the time of the merger with M&B, Bass had just started to produce Worthington 'E' in keg, and after the merger the group concentrated its kegging operations at Burton,

The new 'Middle Chilled Ale Plant' built on the Bass 'Middle' Brewery site in the 1960s, showing two trailer loads of kegs pulled by Scamell Scarabs. (National Brewery Centre)

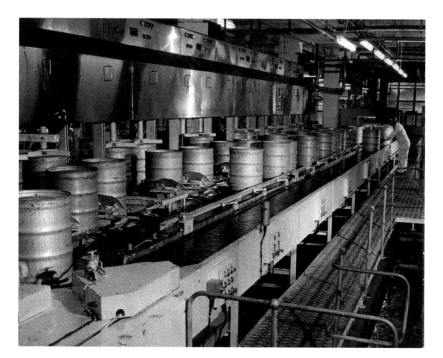

Keg racking line at Bass in Burton. (National Brewery Centre)

WORTHINGTON **E**the taste that satisfies

installing a new, automated kegging plant on the site of Bass's old Middle Brewery, and promoting both Bass and Worthington 'E' as its major keg beers. M&B Mild and Brew XI continued to be produced at Cape Hill as traditional draught beers.

During this time (the mid-1960s) work was begun on a new (lager) brewery in Burton, at the same time as the Worthington brewery was closed. When the new brewery (No. 1) came on stream in 1968, the Bass Old Brewery in High Street was closed – thus ending almost two centuries of continuous brewing.

BM&B made only three acquisitions: Sydney Fussell & Sons of Rode, Somerset, in 1962, with sixty-one licensed houses; Hunt Edmunds & Co. Ltd of Banbury, with 280 licensed premises situated mainly in the Cotswolds; and in 1967 Bent's Brewery Co. Ltd of Liverpool. Bent's had three breweries – in Liverpool, Ashton-under-Lyne and Stone in Staffordshire – with over 500 licensed houses situated around all three, making the company an attractive proposition for any group wishing to extend its trading interests into the north-west.

The acquisition of Bent's by BM&B, after a fierce bidding war with Watney Mann, left the way open for a renewal of discussions between Alan Walker and E. P. Taylor, a Canadian entrepreneur who had recently masterminded the formation of Charrington United Breweries (CUB), and who had first sounded Walker out as early as 1962, on the prospects of a merger.

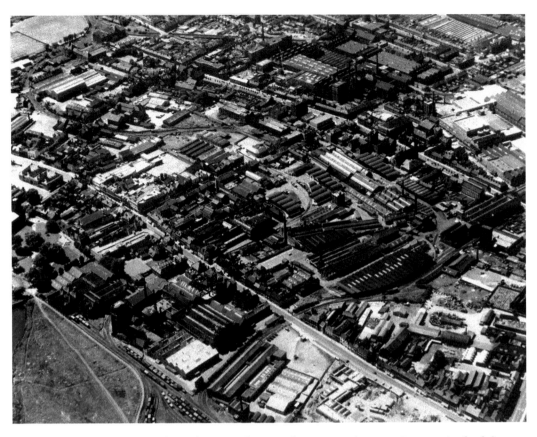

An aerial view of Burton in the early 1960s showing the Bass High Street Brewery in the left foreground, Worthington's brewery to the left of centre, the Bass 'Middle' brewery site in the top right, and the Bass 'New' (or No. 2 as it was now called) brewery in the top middle. (National Brewery Centre)

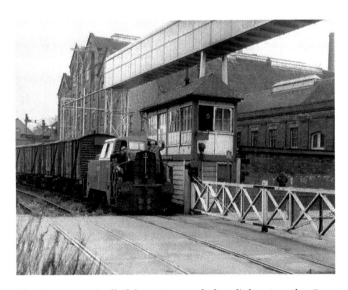

The last train (pulled by a Sentinel diesel) leaving the Bass High Street Brewery in 1964. (National Brewery Centre)

E. P. Taylor and Hope & Anchor Breweries Ltd (H&A)

In the 1930s, a small Sheffield brewery, Carter, Milner and Bird, staked its commercial future on bottled beer, and in 1935 launched a new sweet (or 'milk') stout, which they called Jubilee Stout to mark the jubilee of King George V and Queen Mary. A new brewery was built, which opened in 1939, and in 1942, after Carter, Milner and Bird had merged with Henry Tomlinson Ltd, another Sheffield brewer whose premises had been destroyed by enemy action in 1940, the company's name changed to Hope & Anchor Breweries.

In 1951, Tom Carter, the CEO of H&A, while in Toronto trying to launch Jubilee Stout in the large and growing North American market, met E. P. (Eddie) Taylor, chairman of Canadian Breweries Ltd, a company Taylor had built up over the preceding twenty years (through a series of rapid mergers and acquisitions) into one of the world's largest brewing companies. Taylor had a genial and outgoing personality, and had become well known in Canada as an astute and energetic businessman/entrepreneur. During the war years he had played a vital role in assisting both the Canadian and UK governments organise the procurement and delivery of raw materials, munitions, food and equipment from North America to the UK in support of the war effort.

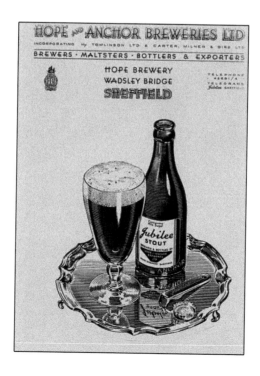

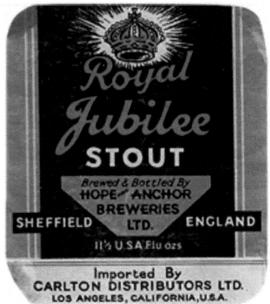

Above left and right: Carling Black Label early graphics and an export Jubilee Stout label. (National Brewery Centre)

Edward Plunkett Taylor (1901–81).
(National Brewery Centre)

Now Taylor wanted to launch his company's leading beer, Carling Black Label lager, into the UK market (which he considered 'ripe for rationalisation'). So he struck a reciprocal agreement with Carter whereby Canadian Breweries undertook to brew Jubilee Stout for the Canadian market and H&A agreed to brew Carling in Sheffield, and to sell it through their own tied outlets as well as, where possible, other brewers' houses. (The first brew of Carling in Sheffield took place in 1953).

From the outset, this arrangement was fraught: Jubilee Stout, being a sweet, dark, heavy beer, was unsuited to the North American market, and Taylor, who had not appreciated the UK's tied house system, became increasingly dissatisfied with the low sales volumes for Carling (H&A's tied estate was relatively small and they lacked the resources to make further significant acquisitions).

A new arrangement was eventually agreed in 1958, a condition of which was that H&A would increase its tied estate by promoting the formation of a national brewing group within the UK. The new agreement was cemented by an exchange of shares, as a consequence of which Canadian Breweries became H&A's largest shareholder and Taylor joined the H&A board, thereby gaining a springboard into the British beer market.

Taylor's arrival on the British brewing scene, and his subsequent activities in promoting mergers and acquisitions, were to have a profound effect on the manner and pace of subsequent consolidation within the industry.

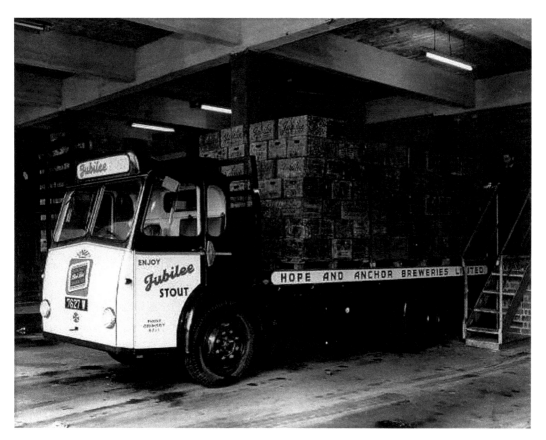

A Hope & Anchor dray wagon in 1955 displaying both Carling Black Label and Jubilee Stout graphics. (National Brewery Centre)

Hammond's Bradford Brewery Co. Ltd

James Hammond started his brewing life as a licensed victualler, but became a common brewer in 1860, when he took over The Fountain Brewery in Manchester Road, Bradford. By 1890 the company had close to fifty licensed houses in and around Bradford city centre.

In the economic downturn that followed the First World War, Hammond's looked for opportunities to develop its trading estate into Bradford's expanding suburbs and those nearby towns whose prosperity was not wholly dependent on Bradford's basic industry: wool. Accordingly, in 1919 Hammond's acquired J. R. Holmes & Sons of Bingley, followed in 1923 by the Ilkley Brewery, and in 1929 they bought the Springwell Brewery Co. Ltd of Heckmondwicke. These acquisitions increased Hammond's estate to 256 tied houses, but also loaded the company with significant debt, just at the time of the stock market crash.

In 1935 H. L. (Harry) Bradfer-Lawrence, in his role as agent for the Aykroyd estate (a Hammond's daughter having married an Aykroyd), was appointed Managing Director of the brewery, and given the task of turning the company's performance around, something he quickly succeeded in doing (helped by the gearing up for war and the sudden flourishing of local industries).

Bradfer-Lawrence had some previous experience in the brewing industry, having been involved in the affairs of Bagge's Brewery in King's Lynn on behalf of the family. However, he was a land agent by profession, with expertise in the buying and development of

Above: Drays drawn up outside the
Fountain Brewery, Bradford, 1940s.
(National Brewery Centre)

Right: Harry Lawrence
Bradfer-Lawrence (1887–1965).
(National Brewery Centre)

properties (including companies), and from the mid-1940s onwards Bradfer-Lawrence began to grow Hammond's through a renewed policy of acquisition.

In 1944 he bought Bentley & Shaw Ltd of Lockwood Park, Huddersfield, a privately owned company with approximately 200 licensed houses in the Huddersfield area, still belonging to the descendants of the original founder, Timothy Bentley, who had built the brewery in 1794.

Then in 1946 Hammonds bought the Tadcaster Tower Brewery Co. Ltd with 260 houses and a brewery that, although showing signs of neglect and under-investment, was on a site that would readily permit future expansion. In 1947 Hammond's also bought the Highfield Brewery of Seth Senior & Sons Ltd at Shepley, near Huddersfield. Following this acquisition the company name was changed to Hammond's United Breweries Ltd.

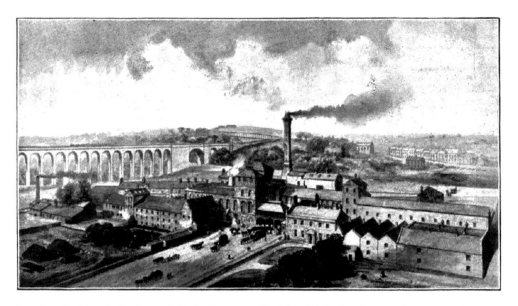

Bentley & Shaw's Lockwood Park Brewery, Huddersfield. A nineteenth-century drawing showing the house of the original owner, Timothy Bentley, in the foreground and the huge Lockwood railway viaduct, which bisected Bentley's original estate (National Brewery Centre)

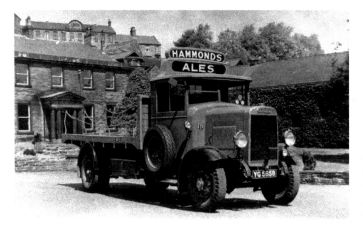

A Leyland Badger flatback, chain-sided dray wagon at Lockwood Park, 1940s. (National Brewery Centre)

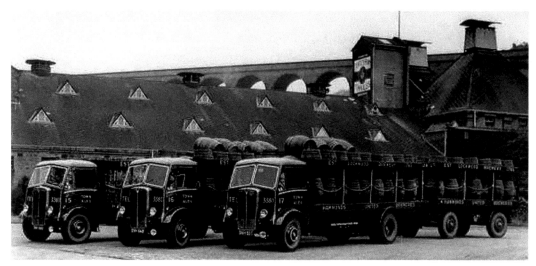

A fleet of fully laden brewery drays (with trailers) drawn up outside Lockwood Park. The sign on the brewery reads Bentley & Shaw Town Ales, but the wagons are signed Hammonds United Breweries. Note the viaduct in the background. (National Brewery Centre)

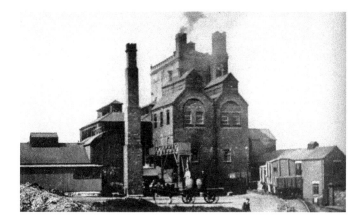

The Tadcaster Tower Brewery, photographed soon after it was built in 1882, showing a rail link into the brewery yard. (National Brewery Centre)

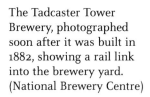

The Tower Brewery, Tadcaster, in Hammond's livery, late 1940s. (National Brewery Centre)

Hammond's United Breweries Ltd (HUB)

In 1954 the old Fountain Brewery in Bradford was closed, and in 1956 two further companies, Bentley's Old Brewery (Rotherham) Ltd (which had been acquired by Timothy Bentley of Lockwood Park in the 1820s) and John Richdale & Co. Ltd of Sheffield were acquired. The company also extended its trading interests into wines and spirits and soft drinks.

In 1958 E. P. Taylor invited H. L. Bradfer-Lawrence and Tom Carter to Toronto to inspect his Canadian business. Bradfer-Lawrence (who by now was over seventy years old) was apparently impressed with the size of the Canadian operation and the resources and expertise available, as well as by Taylor's 'broad brush' approach and entrepreneurial style. However, back in the UK, subsequent talks of a possible merger between HUB and H&A (and one or two other Yorkshire brewers) broke down – the key issues having more to do with power, politics and personalities (who would be chairman of the new company, who would have seats on the board) as opposed to any economic benefits.

HUB continued to seek opportunities to expand, and in 1959 they acquired four more breweries: R.F. Case & Co. Ltd of Barrow-in-Furness, John Aitchison & Co. Ltd of Edinburgh, G. S. Heath Ltd of Barrow-in-Furness, and Westoe Breweries Ltd of South Shields. All these companies brought Hammond's representation in new areas, increased its tied estate to approximately 1,000 houses, and strengthened its status as a semi-regional company.

Towards the end of 1959 Taylor, who during the year had been making unsolicited visits to a number of brewery chairmen across the UK suggesting they might like to merge with him, again met with Bradfer-Lawrence to discuss Taylor's plans for forming a consortium of British brewers. Taylor suggested that John Jeffrey & Co. Ltd of Edinburgh, a company in which he had taken a significant (40 per cent) holding, should also join the proposed new group. While accepting the logic of Taylor's argument, Bradfer-Lawrence was still wary of how the new company would work in practice and determined to protect HUB's interests (principally by insisting he became chairman of the new group). His son, P. L. (Philip) Bradfer-Lawrence, the joint MD of HUB, was a strong advocate of the merger. So was Arthur Elliott, who had succeeded Tom Carter as chairman of H&A. Elliott finally persuaded the H&A board by telling them that the new company would simply be a holding company – each constituent company remaining autonomous and that other brewing companies would soon be persuaded to join – both of which expectations were met.

As a result, in February 1960, Hammonds United Breweries Ltd merged with Hope & Anchor Breweries Ltd and John Jeffrey & Co. Ltd to form Northern Breweries Ltd H. L. Bradfer-Lawrence became chairman, Arthur Elliott vice chairman with E. P. Taylor deputy chairman. P. L. Bradfer-Lawrence was appointed MD.

E. P. Taylor had therefore succeeded in edging his way into the traditional, paternalistic, secretive and in-bred British brewing industry, at a time when similar efforts by other industry outsiders, whose interests were principally aroused by the undervalued and underused property assets of many brewers (especially in London), had failed. Taylor subsequently informed the press 'You can take it from me, this Northern merger is not the end'.

Northern Breweries of Great Britain Ltd/United Breweries Ltd

Taylor now openly declared his intention of forming a national brewing group, and in May 1960, over the course of a week, Taylor, P. L. Bradfer-Lawrence and D. J. Palmar (representing Northern Breweries' merchant bankers) brought three Scottish breweries into Northern Breweries: George Younger & Sons Ltd of Alloa, John Fowler & Co. Ltd of Prestonpans (who brewed a famous strong ale called Wee Heavy), and William Murray & Co. Ltd of Edinburgh. Later in the same year, this group was strengthened by the acquisition of James Aitken & Co. Ltd of Falkirk and James Calder & Co. Ltd of Alloa. Taken together, this group of breweries accounted for over 20 per cent of Scotland's beer output. A regional management company, United Caledonian Breweries Ltd, was formed to coordinate their activities, but at this stage each brewery retained its own brands and a large degree of autonomy.

In the same year Taylor was approached by Webbs (Aberbeeg) Ltd with a view to him acquiring them, and terms were quickly agreed. Also, in October 1960, Taylor purchased the Ulster Brewery Co. Ltd in Belfast, who were already seeing good sales figures for Carling through an agency agreement they had in place with H&A. Following these acquisitions the company's name was changed to United Breweries Ltd.

Despite growing opposition to his 'Canadian upstart' image, in 1961 Taylor succeeded in bringing two small Lancashire breweries into the group: the Cornbrook Brewery Co. Ltd in Manchester and Catterall & Swarbrick Ltd of Blackpool. Also in 1961, United made a successful offer for Hewitt Brothers Ltd of Grimsby, who had recently acquired Moors' and Robson's Breweries of Hull.

An important feature of United Breweries' growth during this time was its expansion into the wine and spirit trade, where the gradual emergence of a mass market was beginning to attract attention from brewers. J. G. Thompson & Co. Ltd, a long-established (1709) wine and spirit merchant of Leith and Glasgow, were acquired in 1960, and in 1961 United Breweries bought Associated Wine and Spirit Shippers Ltd (AWSS), followed soon afterwards by Hedges and Butler Ltd, an old-established (1667) West End wine merchant.

Having now seen United Breweries become a major company within the brewing industry (with 2,650 licensed houses and a market value of more than £30 million) H. L. Bradfer-Lawrence retired as chairman in January 1962 (as did Tom Carter). He was succeeded by E. P. Taylor (H. L. Bradfer-Lawrence died in 1965).

Despite various attempts to allay concerns, Taylor's image in the brewing industry as a 'brash outsider', together with his personality and style, frightened off many companies who might have been induced to join United Breweries. He was not alone in thinking that the future of the industry lay with national groups and national brands, but many of the well-established, family-run, regional brewers wanted nothing to do with him. He was therefore compelled to concentrate his efforts on small, local companies, whose beers were little known outside their immediate trading area. In pursuing this strategy he showed remarkable determination to acquire as many of them as possible – a fact reflected in the prices he offered – but as a result, United's expansion had been somewhat haphazard and opportunistic in nature, and gave limited opportunity for integration.

It was therefore becoming increasingly apparent that if United was to derive any real advantages from its mergers and acquisitions, and to achieve a truly national network of tied outlets for its beers, it would have to link up with another group with extensive interests in those areas of the country where United was still not represented: the midlands, London and the home counties, the south and south-west. Charrington & Co. Ltd were in many respects an excellent potential partner for United, and moreover, were themselves interested in such an alliance.

Charrington & Co. Ltd

In 1757 the brewing company of Wastfield and Moss moved from Bethnal Green to newly built premises in the Mile End Road: the Anchor Brewery. In 1766 John Charrington (who had served an apprenticeship at a brewery in Islington) purchased a third share and, following the retirement of both the original founders, in 1783 the company became wholly owned by John and his brother Harry. It was to remain a family-controlled company for the next 180 years.

John Charrington (1739–1815). (National Brewery Centre)

Rather than trying to compete with the large-scale London porter brewers Wastfield & Moss, and after 1783 Charrington, concentrated on supplying the private family trade in the London suburbs and beyond, who hitherto had either brewed their own beer or bought beer direct from a local wholesale brewer. As home brewing declined dramatically towards the end of the eighteenth century (as a result of it now being taxed at the same rate as commercial brewers), the private family trade grew in importance, the staple product being 'table beer' – a lower gravity, lighter beer than porter, suitable for consumption with food. In pursuing this market Charrington was evidently successful, since by 1814 the Mile End brewery was producing 16,500 barrels per year of ale and 'table beer', mainly for the family trade.

In 1830 the passing of the Beerhouse Act (which enabled any property owner, on purchase of a 2 guinea excise licence, to retail beer for consumption on or off the premises) enabled Charrington to gain a foothold in London's new and now rapidly expanding licensed retail trade, which hitherto had been heavily restricted, with a large proportion tied to the big city porter brewers.

In 1833 Charrington's acquired Steward & Head of Stratford-upon-Avon and traded as Charrington Head & Co. until 1880.

By the 1890s, Charrington & Co. owned sixty-one licensed houses in London, and in 1897 the company incorporated itself, thereby raising additional funds with which to join the bidding war for licensed properties in theLondon area.

They also bought more than eighty licensed houses in the midlands and north in order to secure outlets for a brewery in Burton, which they had bought and rebuilt in 1872. The original reason for acquiring the Burton brewery was to enable Charrington to supply their London trade with Burton pale ale of their own making. However, as competition for the

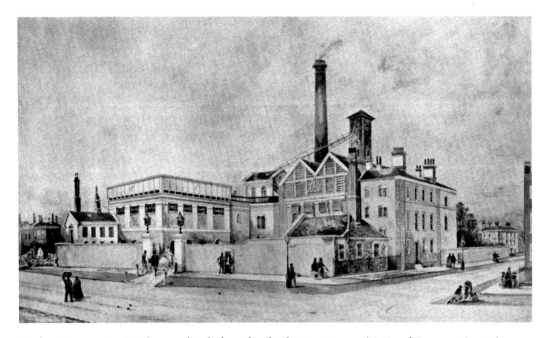

Anchor Brewery in 1856 from a sketch done for the first centenary. (National Brewery Centre)

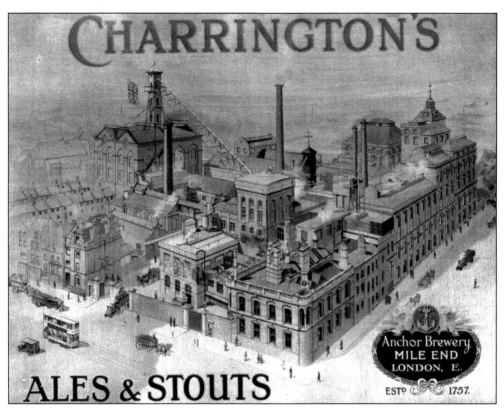

The Charrington Mile End Brewery, 1910–20. (National Brewery Centre)

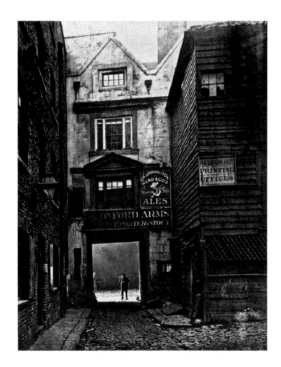

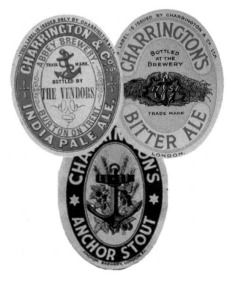

Left: The Oxford Arms in Warwick Lane near St Paul's Cathedral, a famous coaching inn demolished in 1876. (The Royal Academy of Arts)

London pale ale trade grew ever more intense and transporting beer by rail from Burton was expensive, they found it difficult to compete with the by now well-established Burton brewers. In 1926 the Burton brewery was closed and sold, together with eighty-seven licensed houses in the midlands and north.

At the same time Charrington took steps to strengthen its presence in east London by acquiring Savill Bros. Ltd of Stratford (in 1925) and Seabrooke & Sons Ltd of Grays, Essex, in 1929. The company took a further major step forward in 1933 when it acquired Hoare & Co. Ltd, who owned the famous Red Lion brewery (dating from 1492), as well as the Toby Jug trademark. This acquisition brought with it a substantial block of licensed houses in the City of London, and necessitated doubling the capacity of the Anchor Brewery (the Red Lion brewery was closed). Subsequently, Charrington acquired Hoare's subsidiary company Page and Overton, which gave them a significant presence in the Croydon area.

During the Second World War Charrington's lost a large number of licensed premises due to enemy action. Also, in the immediate post-war years a combination of bomb damage, urban redevelopment and the decline of the old docklands area resulted in a major shift in London's population to the south and west of the city – areas in which Charrington was poorly represented. The company therefore looked to areas outside of London for opportunities to expand, and in 1950 they acquired Thompson & Son of Deal, Kent, together with 100 houses, and in 1954 acquired the Kemp Town Brewery in Brighton, gaining another 200 houses. Also at this time Charrington signed a UK franchise agreement with Canada Dry Inc., thereby gaining a foothold in the growing soft drinks market.

It should be emphasised that all the above acquisitions were made in the traditional manner – based either on family connections or on 'gentlemen's agreements'. The idea that a friendly arrangement between two companies could be challenged by a third party

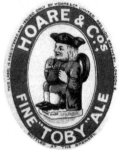

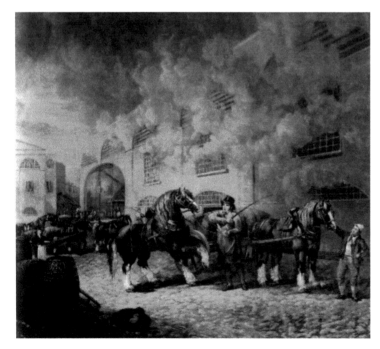

Left: The Red Lion Brewery Yard, East Smithfield, 1805, by Dean Wolstenholme, the elder. In 1784 the Red Lion Brewery was the first of the London brewers to install a Watt & Boulton steam engine. Charrington's followed a decade later.

The frontage of the Mile End Brewery in 1957. (National Brewery Centre)

was still entirely foreign to the brewing industry. Consequently, the pace of change was relatively slow, and most mergers aroused little external interest – a situation which was to change dramatically as the decade progressed.

Continuing with their strategy of escaping the confines of east London, in 1960 Charrington bought the Barnstaple brewery of Yeo, Ratcliffe and Dawe, and at the same time The People's Refreshment House Association (PRHA), a chain of 109 licensed hotels spread across thirty-two counties, but mostly in the West Country. This was followed in 1961 by Charrington's largest West Country acquisition: Bruton, Mitchell Toms Ltd of Yeovil, a brewer and cider maker with approximately 300 licensed houses. To complete this acquisition Charrington had to make a counter offer to one already made by their rivals Courage, and in so-doing caused acrimony by breaking with the long-standing brewing industry tradition referred to above.

By 1961, therefore, Charrington had succeeded in extending its trading area beyond east London and Essex, and its total tied estate was now around 2,400 licensed houses. Nevertheless, the board concluded that sooner or later they would have to link up with another major group with trading interests outside the London area. Thus, when they were approached by United Breweries in 1961, the Charrington board reacted favourably, and in January 1962 the formation of Charrington United Breweries (CUB) was announced.

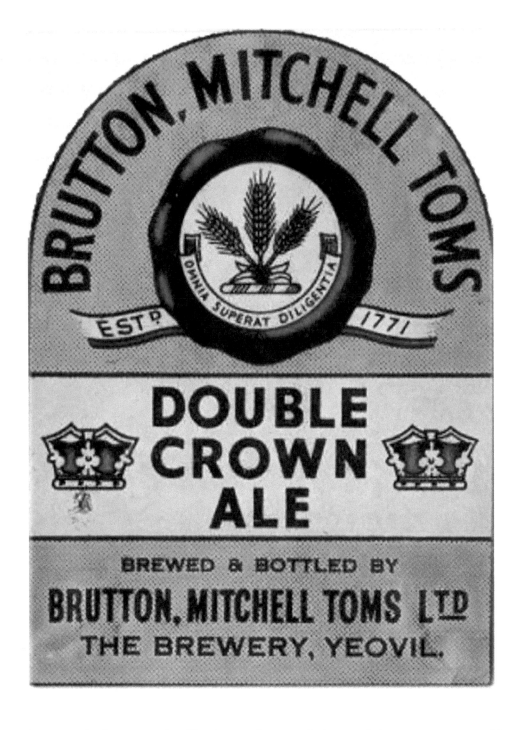

Charrington's chairman, John Charrington, became chairman of the new company, with E. P. Taylor deputy chairman. CUB had both a London base and a national distribution network, enabling it to promote national beers, and was comparable in size with its competitors – Watney Mann, Courage Barclay Simonds and the newly formed Bass, Mitchells and Butlers.

Charrington United Breweries (CUB)

A process of rationalisation now began in the new company, albeit geared to the needs of the various regional companies, which were left to run as autonomously as possible within an overall 'group' framework. It was also recognised that the group still needed to acquire more breweries, particularly in the north and Scotland.

In May 1962 Hardy's Crown Brewery Ltd of Manchester joined the group, and a year later what turned out to be an extremely valuable acquisition was made: J. & R. Tennent's Ltd of Glasgow, which was seeing increasing demand for its Tennent's Lager – particularly when it was offered in draught form from 1963 onwards.

Tennent's had a long and proud history (the brewery site in Glasgow went back as far as 1566) and, like a number of other Scottish brewers, the company had developed worldwide export markets for its beers (Tennent's had first exported beer in 1797 to the Caribbean and America).

However, in the post-war years many of these overseas markets had dwindled, as local brewing companies began to develop under the protection of high import tariffs. As a consequence Tennent's had recently extended its trading base in Scotland by acquiring Maclachlan's, an Edinburgh brewer with a sizeable managed estate (mostly in Glasgow). However, this acquisition had stretched Tennent's financially, limiting their ability for further development and expansion, hence the attraction of a merger with CUB.

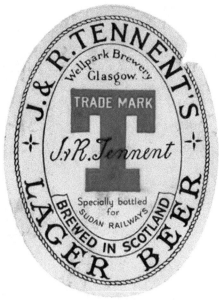

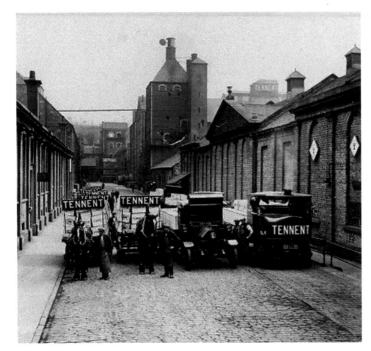

Above left: Three types of drays outside the main entrance to Tennent's Wellpark Brewery, c. 1920. (National Brewery Centre)

Above right: Tennent's pioneered beer in cans in the UK – this example is from 1935. (Courtesy of A. A. Meldrum)

Following this acquisition, work began on planning the longer-term production and distribution requirements of the Scottish group, in order to realise the benefits of integration and rationalisation. The Heriot Brewery (of John Jeffrey & Co. Ltd) underwent a major refit in 1964, and in January 1966, a new Scottish regional company, Tennent Caledonian Breweries Ltd, was formed. The first phase of the expansion of Tennent's Wellpark brewery was completed in 1967.

In the south, following the closure of Brutton, Mitchell Toms' brewery and the Kemp Town brewery, production was centred on Mile End, and in Yorkshire the Tadcaster brewery was designated the production centre for the region. During 1965/66 its capacity was increased to 800,000 barrels per year, thereby enabling the closure of the breweries in Huddersfield (Lockwood Park), Hull and Grimsby. Thus, when Offiler's Brewery in Derby was acquired in 1965 and the brewery subsequently closed, the accompanying 240 houses were supplied from Tadcaster.

In Lancashire, however, the constituent companies were too small and geographically isolated for major rationalisation, and they all continued to produce their own beers for their own particular trading areas (including Massey's of Burnley, which was acquired in 1966). Only the Hardy Brewery was closed down.

A significant problem for CUB was that neither of the two main constituent companies had a draught bitter that was acceptable to all parts of the group, and therefore had the

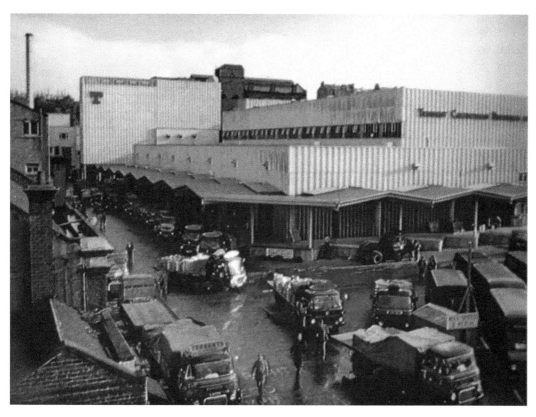

Tennent's Wellpark Brewery, Duke Street, Glasgow, 1967. (Courtesy of A. A. Meldrum)

Above: The new brewhouse under construction at Tadcaster in 1965. (National Brewery Centre)

Left: Carling's iconic 'ice cube' font. Carling was first sold on draught at the Hillside Sports & Social Club in Sheffield in 1965. (National Brewery Centre)

potential to become a national brand. Only Carling lager had any real growth potential and once it was sold in draught (keg) form (from 1965 onwards) sales started to increase. But demand for lager was still very seasonal and weather-dependent, and the lager market was becoming increasingly competitive.

In June 1967, during a cricket match at Hope & Anchor Breweries, the Hope chairman (Arthur Elliot, who was also on the main board of CUB) invited Alan Walker to play in his team, and while fielding and between overs, discussed the possibility of a merger. Elliot subsequently contacted E. P. Taylor, who met with Walker, and the terms of a merger – the largest the UK brewing industry had ever seen – were quickly agreed.

Alan Walker was appointed chairman of the new company, Bass Charrington, while Taylor retained a seat on the board. (Taylor finally retired to his home in the Bahamas in 1972, having seen his optimism and persistence in building the biggest brewing group in the UK finally realised.)

The merged company gained an excellent geographic spread in terms of production and distribution facilities, as well as 11,272 licensed houses. It had a lager with great potential as a national brand, together with two premium, nationally recognised draught bitters in Bass and Worthington. These were complemented by a broad mix of regional bitter brands, each with strong local followings. The company also had strong holdings in the growing markets for soft drinks, wines and spirits, and the merger brought the potential for substantial economies of scale in production, which, once realised, were expected to significantly improve the return on capital employed.

John Charrington, E. P. Taylor and Alan Walker on the day of the merger, 1967. (National Brewery Centre)

Bass Charrington (BC)/
Bass plc/Bass Brewers Ltd

The formation of Bass Charrington took place against a background of significant industrial, economic and social change, and was the culmination of an industry-wide trend towards the formation of a few national or semi-national brewing companies, a key stimulus for which was the desire to increase market share in an industry where demand was at best growing slowly, and competition was heavily restrained by restrictive licensing laws.

It was anticipated that the market strength of the merged company would be greater than that of BM&B and CUB had they not merged, these additional gains (or 'synergies') being realised through rationalisation and integration of the new company's brewing, packaging and distribution operations.

Post the merger, only three more brewing companies were acquired, each with a view to filling gaps in the group's national trading pattern: William Hancock & Co. Ltd of Cardiff, in 1968, with 600 houses and extensive free-trade interests in South Wales, and with whom

Bass already had a trading relationship; William Stones Ltd of Sheffield, also in 1968, which owned nearly 300 houses in and around Sheffield; and John Joule & Co. Ltd of Stone in Staffordshire, in 1970, which owned 230 houses.

The upturn in demand for beer, which began in the late 1950s, was driven in particular by the increasing popularity of keg beers and especially lagers. Both of these developments required investment in new plant and technology, and added weight to the argument for fewer but larger volume breweries. Increased opportunities for automation of the brewing process, together with an escalation in both raw materials and labour costs, were additional factors that, at the time, favoured the construction of breweries capable of high volumes, thereby achieving 'economies of scale', while simultaneously closing down smaller, inefficient, poorly located breweries inherited from 'legacy' companies.

Bass Charrington's Runcorn Brewery, 1984. (National Brewery Centre)

For all the reasons already mentioned, at the outset, the cornerstone of Bass Charrington's long-range production strategy was the construction of a 2.5 million barrels per year brewery at Runcorn in Cheshire. After construction delays, caused principally by a disastrous fire, the brewery at Runcorn came into full production in 1975, and the decision to build it was initially vindicated by its ability to keep the company's licensed houses supplied with beers (mainly Carling and Worthington 'E') during the long hot summer of 1976. The group's bottling and canning were also mainly centralised at Runcorn, and as a consequence the breweries in Manchester (Cornbrook), Liverpool (Bent's), Barrow (Case's), Blackpool (Caterall & Swarbrick), Burnley (Massey), Mile End (Charrington) and Aberbeeg (Webb's) were all closed.

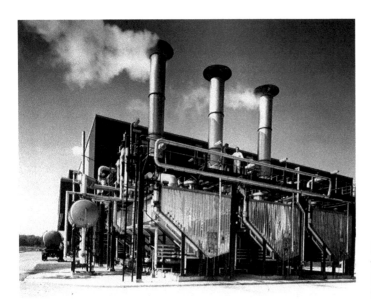

Runcorn's Steineker wedge-shaped coppers. (National Brewery Centre)

The beer transfer mains and cylindroconical fermenting vessels at Runcorn. (National Brewery Centre)

Bright Beer Tanks at Runcorn – there were thirty-six in total feeding nine packaging lines. (National Brewery Centre)

In addition to Runcorn, this left BC with breweries in Belfast (the Old Mountain brewery), Edinburgh (Heriot), Glasgow (Wellpark), Tadcaster (Tower), Sheffield (Hope & Anchor and William Stones' Cannon brewery), Burton (Bass), Birmingham (Cape Hill), Wolverhampton (Springfield), Walsall (Highgate), and Cardiff (Hancock's). In 1978 BC also bought a brewery in Alton, Hampshire, from the Harp Lager Consortium, primarily to meet the requirements of the trade in London, the south and south-east.

However, from its inception, the brewery at Runcorn was beset with difficulties. These stemmed variously from its sheer size and scale, its inflexible design and layout, its reliance on new and unproven technologies, its location, and its intransigent (and at times belligerent) workforce. For all these reasons Runcorn never achieved the so-called 'economies of scale', which were in large measure the justification for its construction, and so never realised the role initially envisaged for it of becoming the company's major production base.

Rather, it was effective management of and investment in the network of breweries comprising BC that became the lynchpin of the company's production strategy. Although these sites varied in size, complexity and capability, together they gave BC the capacity and flexibility to produce a range of beers able to satisfy regional as well as national (and international) tastes and preferences.

After one brief, unsuccessful, attempt to foist a new, standardised bitter (Brew Ten) across its northern customer base, BC came to recognise the importance of regional tastes and preferences, so that rather than concentrating exclusively on its national brands (draught Bass, Worthington, and Carling), a wide-ranging portfolio of regional beers were retained, many of which, in the decades that followed, became brand leaders in their particular areas: Tennent's lager in Scotland, Stones Best Bitter in the north, M&B Mild and Brew XI in the midlands, Charrington's IPA in London and the south-east, and Allbright in South Wales (see Appendix 1 for further details).

Sir Alan Walker retired in January 1976 and was succeeded by Derek Palmar (who during the 1960s had worked with E. P. Taylor and P. L. Bradfer-Lawrence on the implementation of Northern and United Breweries' acquisitions plans, as well as those of CUB).

An aerial view of the Tadcaster brewery site in the early 1970s showing the old and new brewhouses (the old Tower brewhouse was demolished in 1974). (National Brewery Centre)

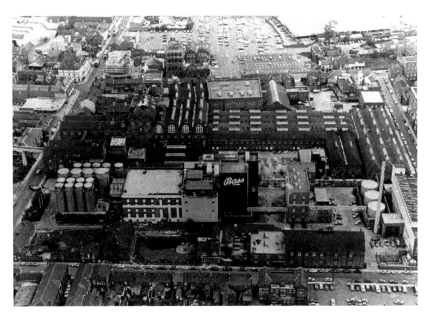

The Bass No.1 and No. 2 breweries in Burton in the 1970s. No. 2 brewery was closed in 1982. (National Brewery Centre)

When you walk into a Bass Charrington pub you can buy the best beers in the country.

Famous names such as Worthington 'E', Carling Black Label and Bass Export. So when you are away from home you don't have to settle for something unknown.

Customers in every area can enjoy the best of both worlds—big national names and flourishing regional brands.

By giving people what they want, Bass Charrington continue to grow.

You will find their products in supermarkets, hotels, off-licenses, as well as in pubs.

With Bass Charrington around, the choice is yours.

Bass Charrington
offer more than just a widespread choice of pubs.

Sir Derek J. Palmar (1919–2006). (National Brewery Centre)

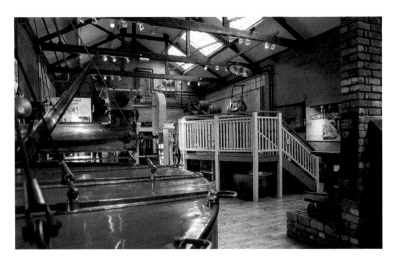

The Bass Museum, based in what was the Joiner's Shop. The mash tun in the foreground of the picture below is from No. 2 brewery, Burton. (National Brewery Centre)

In 1977, to mark the bicentenary of the opening of the first Bass brewery, the company opened a museum of brewing on the Burton brewery site, 'the Bass Museum', to show its pride in its past and to help stimulate public interest and awareness of the role the brewing industry has played in the UK's social history.

Increasingly, Bass Charrington came to see itself not just as a brewer, but as part of the larger (and growing) leisure industry. As a consequence, in addition to developing its beer brands, the company invested heavily in its public houses, broadening their appeal by improving the standard and range of their amenities to include music, entertainment and food. BC also invested heavily in wines, spirits and soft drinks, significantly widening its product ranges in all these categories, as well as in hotels (the Crest Hotels chain was first launched in 1969 and thereafter developed rapidly). In recognition of this broader portfolio of activities, by the time the company name was simplified to Bass plc in 1979, an increasingly diverse range of leisure interests were represented at board level.

Canned Carling coming off the new 2,000 cans per minute line installed in Burton in 1990. (National Brewery Centre)

The growth in overall beer volumes seen during the 1960s and 1970s was not sustained into the 1980s; nevertheless, sales of Carling continued to grow, and it became the UK's bestselling beer in the late 1970s – a position it has held ever since. In so doing Carling became the first UK beer with sales exceeding 1 million barrels per year, a figure which had increased to nearly 4 million barrels per year by the late 1990s. A significant factor contributing to its later growth was the increasing popularity of canned beer in the expanding 'take home' market.

The original bottle-conditioned 'red triangle' Bass Pale Ale was finally delisted in the mid-1970s, having been 'morphed' into its Worthington equivalent: Worthington's White Shield.

Nevertheless, cask-conditioned Draught Bass remained popular (and in 1967 even spawned its own unofficial appreciation society: The Honourable Order of Bass Drinkers). Moreover, a chilled and filtered version of the original strength, bottle-conditioned Bass

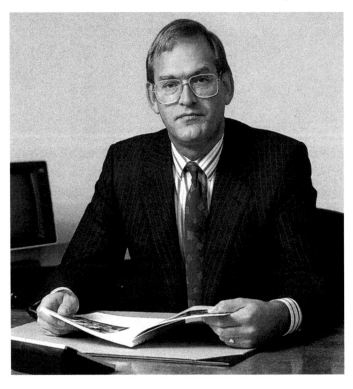

Sir Ian M. G. Prosser (1943). (National Brewery Centre)

(Export Bass Pale Ale) sold well in markets around the world – especially in the USA where volumes reached approximately 400,000 barrels per year in the late 1990s.

By 1987, when Ian Prosser succeeded Derek Palmar as chairman, Bass owned and operated the largest pub chain in the UK (>7,000 outlets), and leisure/hospitality activities began to assume a greater role in the company.

In the same year Bass announced an agreement with the US-based Holiday Corporation to purchase eight European Holiday Inn hotels, and in 1990 the company dramatically increased its hotel holdings when it acquired the worldwide Holiday Inn chain (for $2.3 billion). This included not only the rights to the Holiday Inn brand name and fifty-five company-owned hotels, but also the franchise rights to more than 1,400 Holiday Inn hotels worldwide.

In 1989, Bass plc, in common with most of the UK brewing industry, was dealt a severe body blow by the government's 'Beer Orders' resulting from a MMC investigation of the industry, in particular the tied house system. Bass plc decided to remain as both a brewer and beer retailer, but as a consequence, was required to sell around 2,700 of its licensed premises. The company, which hitherto had been, in essence, a number of vertically integrated local operating companies, was subsequently restructured, such that all brewing, brand owning, distribution and wholesaling operations were constituted into one division: Bass Brewers Ltd. Following the disposal of its leased pub operations and 300 managed houses, the company's remaining pub retailing operations were formed into a new pub and restaurant division: Bass Leisure Retail.

The enforced sale of licensed houses resulting from the Beer Orders inevitably meant the closure of a number of the group's breweries, so that by the year 2000 only Belfast, Glasgow, Tadcaster, Burton, Birmingham and Alton remained.

During the 1990s Bass bought breweries in the newly opened Czech Republic, as well as establishing a joint venture in China – the world's second largest beer market. The company also continued to expand its soft drinks interests through its management of Britvic Soft Drinks Ltd.

Highgate Brewery, Walsall, sold in 1995. (National Brewery Centre)

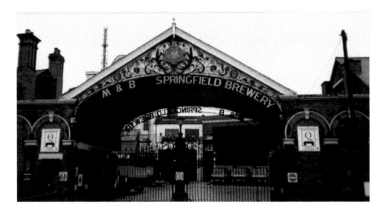

Springfield Brewery,
Wolverhampton,
closed in 1992.
(National Brewery
Centre)

Heriot Brewery,
Edinburgh, closed
in 1992. (National
Brewery Centre)

Hope & Anchor Brewery
Sheffield, closed in 1992.
(National Brewery Centre)

Above: Cannon Brewery, Sheffield, closed in 1999. (National Brewery Centre)

Right: The Crawshay Street Brewery, Cardiff, sold to Brains in 1999. (National Brewery Centre)

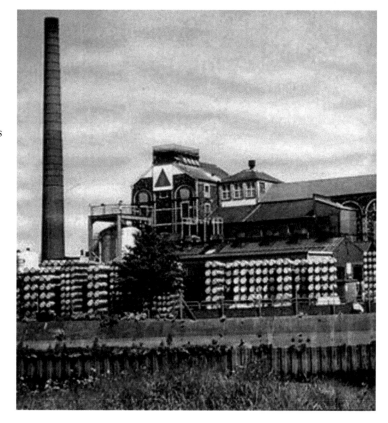

During the same period, in order to compete in an increasingly food-led and diversifying licensed trade, the company acquired new pub chains: Harvester pub restaurants and Browns Bar and Brasserie. It also launched its own branded pub chains: Vintage Inns, O'Neill's, Ember Inns and All Bar One.

In 1996 Bass reached an agreement to buy 50 per cent of Carlsberg-Tetley, a major UK competitor, but the deal was blocked by the Secretary for Trade & Industry, citing anti-trust reasons.

In 1998 Bass completed another major hotels acquisition when, after an intense bidding war, it bought the Intercontinental Hotels and Resorts chain from the Saison Group of Japan, thereby significantly bolstering its presence in the high end of the hotel market. Intercontinental became part of the newly named Bass Hotels & Resorts division.

The net result of these acquisitions was that, by the year 2000, Bass operated the world's second largest hotel group, with nearly 3,000 properties and 480,000 rooms, and it was the company's hospitality divisions (Bass Hotels and Resorts and Bass Leisure Retail) that were driving the company's growth.

It was against this backdrop, with UK beer volumes again in the doldrums and in the midst of a worldwide consolidation drive taking place within the brewing industry, that Bass plc took the decision to sell Bass Brewers Ltd.

At the beginning of the year 2000 Interbrew S.A. (as it then was) acquired Whitbread's brewing and brands interests. As a consequence, when later that same year Interbrew also purchased Bass Brewers Ltd (for £2.3 billion), the UK Competitions Commission raised potential monopoly concerns. As a result, Interbrew, while being allowed to retain the rights to the Bass Pale Ale brand name, was forced to divest itself of all the England- and Wales-based operations of Bass Brewers Ltd, leaving it with the breweries and sales operations in Northern Ireland and Scotland, as well as Bass Export's operations worldwide.

Following its acquisition by Coors Brewing Co. of Denver, Colorado, in 2002, Bass Brewers Ltd was renamed Coors Brewers Ltd Draught Bass continued to be brewed in the Burton brewery, albeit now under licence to Interbrew, but when this licensing arrangement came to an end in 2005, brewing was transferred to another Burton brewer: Marston's – once a competitor of Bass.

After the sale of Bass Brewers Ltd, Bass plc was renamed Six Continents plc. In 2003, Six Continents demerged its pubs operation (which was renamed Mitchells & Butlers plc) and in 2005, having also split off its soft drinks operation (which became Britvic plc), Six Continents took the name Intercontinental Hotels Group.

Given its history and reputation in the brewing industry worldwide, the decision by Bass plc to sell Bass Brewers Ltd came as a shock to people within as well as outside the industry. However, when viewed within the context of ongoing regulatory restrictions together with continuing downward trends in the UK beer market, the rationale becomes more apparent. Moreover – and with the benefit of hindsight – subsequent developments in the UK brewing industry only add weight to the decision: further dramatic reductions in overall beer volumes, the growing power of 'PubCo.s' in the on-trade, and the huge swing from on to off trade sales.

In Summary

The time period over which this story unfolds (1770s–2000s) was one of unprecedented social and economic change: from the beginnings of the Industrial Revolution with its attendant move from a farming-based to industrial economy, right through to the computer age. During this period brewing developed from a cottage craft into an industry, partly as a consequence of, but also in order to meet the needs of, the Industrial Revolution.

Partly by virtue of good luck and circumstance, but also through shrewd judgement, sound management and sheer endeavour, Bass & Co. rose to meet that need, in so doing creating and exploiting a tidal wave of popularity for its beers, developing what became a world-renowned brand name, and making Burton-on-Trent the brewing capital of the world. The fact that the Bass name (and logo) was retained by the successive companies that picked up that original mantle (and that the name still survives today as a much-respected brand), is testimony to the reputation the company acquired in its Victorian heyday.

At their outset Bass & Co. set out to be brewers, selling their beer in a free market, and as such were reluctant to become involved in the licensed trade with all its attendant managerial complexities and responsibilities, as well as its financial dependency on the vagaries of the property markets. However, as the overall beer market began to stagnate, it was inevitable that brewers would seek to secure outlets for their beers through direct ownership of public houses, whether as a matter of deliberate policy – as with M&B and Charrington – or as a consequence of having to deal with trade debts.

The complacency and lack of direction shown by the Bass board in the period between the wars, and the company's decline during the 1950s when it was living on past glories, left Bass & Co. both vulnerable and exposed as a target for either merger or acquisition

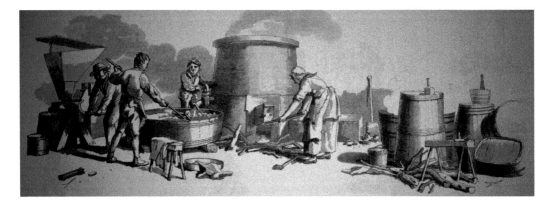

(a proposal to merge with Watney Mann had already been drawn up but dropped before Alan Walker approached Sir James Grigg).

As the 1960s dawned, the winds of change began to blow through the brewing industry – the days of traditional paternalism, cosy, local, tenanted pubs and modest profits being replaced by the disciplines and financial rigours of big business (and ever-rising beer prices). The drivers for this change were partly external to the industry: a buoyant stock market, a greater focus (and openness) in financial reporting, and increases in property prices. But there were also a number of developments specific to the industry itself: an easing of licensing restrictions, the increasing popularity of keg beer and lager, the growth of the off-trade, the need to improve pubs and their profitability, all taking place against a background of a growth in the population, increasing prosperity, and changes within the social structure – in particular a new generation of beer drinker.

Neither of the two individuals (E. P. Taylor and H. A. Walker) who exerted most influence in perpetuating and transitioning the Bass name into the latter half of the twentieth century started their professional lives in the brewing industry. Nevertheless, they both understood the industry, its trading and regulatory frameworks, and the business goals within which brewing companies now had to operate. They also shared a common vision, based on achieving size and reach in an increasingly competitive and brands-led market.

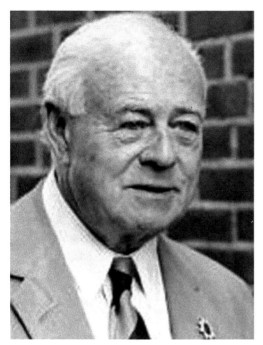
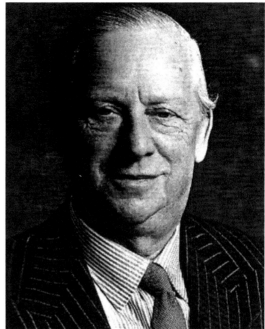

Taylor's advocacy of the concept of a national brewing group had a profound effect on the entire British brewing industry in the late 1950s/early 1960s, while the success of the Bass Charrington merger was attributed at the time of Walker's death to 'his outstanding ability in integrating the constituent parts of these two large groups.' His management style while chairman of M&B, BM&B and BC was very much of that era: 'command and control' – in other words he provided firm and decisive leadership, did not encourage debate, and did not think twice about breaking with tradition.

The later decades of the twentieth century saw a growing realisation within the brewing industry that beer and pubs were now part of a bigger (and growing) leisure industry, and that to succeed brewing companies had to embrace a far broader remit than simply brewing beer for men in pubs (their principal role in Victorian times). Consequently, brewers invested heavily in public houses, their amenities and staff in order to broaden their appeal, an impetus that was severely disrupted by the government's Beer Orders of 1990, which resulted in the industry as a whole having to sell approximately 22,000 pubs.

That a company that had steered away from public house ownership in Victorian times and focussed on selling its beers in a free market was obliged to rethink its business plans at the end of the twentieth century because its licensed house estate was now being reined in by the prevailing government's enthusiasm for market forces is a strange twist of fate.

In addition to the six breweries shown on pages 81 to 83, Bass closed its Runcorn/ Prestonbrook brewery in 1992 and, following the break-up of the company in 2001, Interbrew closed the Belfast brewery in 2004, and Coors Brewers Ltd closed the Cape Hill brewery in 2002 and the Alton brewery in 2015.

That leaves just three out of the thirteen breweries that constituted the Bass group of the 1970s still operating: Tennent's Wellpark (now owned by the C&C Group) and the

Tadcaster brewery, now owned and operated by Molson Coors. Molson Coors are also still brewing in Burton, but have closed what was the Bass No. 1 brewery site, using instead what was the Ind Coope brewery, which they have integrated with a huge beer processing and packaging operation on what was the Bass 'middle' brewery site.

Sources and Suggested Further Reading

Avis, Anthony, *The Brewing Industry 1950–1990* (privately published, 1997)

Barnard, Alfred, *Noted Breweries of Great Britain & Ireland* (London: J. Causton & Sons, 1889)

Gourvish, Terry, and Wilson, Richard, *The British Brewing Industry 1830–1980* (Cambridge: University Press, 1984)

Hartland, Trevor, and Davies, Keith, *A History of Cape Hill Brewery* (Kings Norton, Birmingham: Heron Press, 2004)

Hawkins, Keith, *A History of Bass Charrington* (Oxford: Oxford University Press, 1978)

McMaster, Charles, and Rutherford, Tom, *The Tennent Caledonian Breweries* (Glasgow: The Scottish Brewing Archives (part of Glasgow University Business Archives), 1985)

Owen, Colin, *The Greatest Brewery in the World: A History of Bass, Ratcliff & Gretton* (Chesterfield: Derbyshire Record Office, 1992)

Putman, Roger, *The Honourable Order of Bass Drinkers* (London: The Brewer & Distiller International, August 2015)

Rohmer, Richard, *E. P. Taylor* (Toronto: McClelland & Stewart Ltd, 1978)

Strong, Leonard, *A Brewer's Progress, 1757–1957, A Survey of Charrington's Brewery on the occasion of its bicentenary* (London: privately published, 1957)

Swales, Will, *History of The Tower Brewery, Tadcaster* (Burton-on-Trent: Bass Brewers Ltd, 1991)

Young, Mark, *Good Honest Beer: The Story of a Midlands Dynasty* (Birmingham: Broad Street Publishing, 2011)

Appendix 1: The 'Classic' Beers Brewed by Bass plc

In 2020 the author conducted a straw pole amongst a number of ex-Bass colleagues from across the production, technical, sales, marketing and communications functions, to seek their views as to the 'classic' beers produced by the company during the last thirty years of the twentieth century.

The final list, based in part on personal preferences as well as on popularity and profitability in the marketplace, consists of a mix of national and regional brands. In alphabetical order they are as follows:

Allbright Bitter – the keg version of cask Hancock's PA, 'the most popular pint in Wales', and the saviour of Hancock's brewery, Cardiff.

Bass No. 1 – the definitive and classic barley wine.

Draught Bass – 'our finest ale', the founding father and bedrock of the company.

Carling Black Label lager – from nowhere to everywhere, selling 3.8 million barrels per year by the end of the 1990s.

Charrington's IPA – a popular cask bitter and well-known brand name in the south-east.

Fowler's Wee Heavy – sometimes called 'happy days', one of the last of the classic Scotch Ales.

Highgate Mild – a cracking cask mild, with a cult following in the West Midlands.

M&B Mild – the last of the high-volume cask milds, accounting for approximately a third of Cape Hill's output in the early 1970s.

Springfield Bitter – had a strong following in the West Midlands, and was popular in Birmingham following its transfer to Cape Hill.

Stones Best Bitter – a classic easy-drinking Yorkshire cask bitter, 'the beer we drink around here', reached 800,000 barrels per year by the late 1970s and was the saviour of both Hope & Anchor and Cannon breweries.

Tennent's Lager – 'the No. 1 lager in Scotland since 1885'.

Tennent's Special 70/Ale – became Scotland's No. 1 keg ale.

Tennent's Sweetheart Stout – originally brewed by Younger's of Alloa, and transferred to Tennent's in the 1960s, it developed a very loyal following.

Worthington 'E' – a great cask bitter, which was repackaged and marketed first by BM&B and then by BC as the company's premium national keg bitter in the 1960s/70s.

Worthington's White Shield – the original bottle-conditioned 'red triangle' Bass India Pale Ale under another name, still with a loyal, albeit diminishing, following.

About the Author

Harry joined Bass in Burton in the mid-1970s and was subsequently based for two years at the Hope & Anchor Brewery, Sheffield, before spending most of the 1980s at the Bass Runcorn brewery. He returned to Burton in 1989 as Director of Quality for Bass Brewers Ltd, the role he occupied until the takeover by Coors Brewing Co. in 2002. He was subsequently appointed Global Director of Technical Compliance for Molson Coors, a position he held until his retirement at the end of 2007.

A Hammond's dray crew making a delivery in the 1950s. (National Brewery Centre)

During his time with Bass (twenty-five years) Harry was a frequent visitor at all the company's breweries (thirteen in the 1980s and early 1990s), and heard various (and sometimes conflicting) versions of the story told in these pages. However, he was never able to pull together all the places, timelines and personalities into one cohesive whole until now – a project he has found both fascinating and informative. He hopes it is a story of interest to a wider audience and serves as a tangible record of what was a tremendous company to have been a part of during the last quarter of the twentieth century, and what was (and still is) a great brand name: 'the best bar call in the world'.

Currently Harry is chairman of the National Brewery Heritage Trust (www. nationalbreweryheritagetrust.co.uk), a registered charity based at the National Brewery Centre in Burton (formerly the Bass Museum). The archives held at the NBC (an online catalogue for which can be accessed via www.nbcarchives.co.uk) have been the source of many of the illustrations used in this book, proceeds from the sale of which will go towards their protection and preservation.